THE RAILWAY PAINTINGS OF
ALAN FEARNLEY

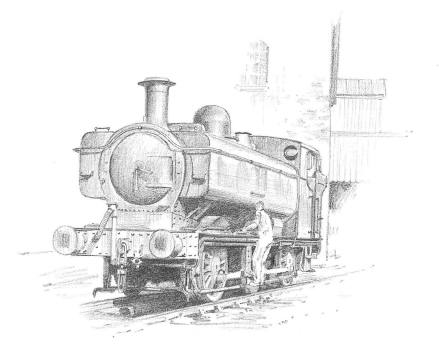

THE RAILWAY PAINTINGS OF
ALAN FEARNLEY

David & Charles

First published in 1987
New edition 1992

British Cataloguing in Publication Data

A catalogue record for this book is available
from the British Library.

ISBN 0-7153-0022-9

Sunset at Nine Elms (p. 70) is reproduced
by kind permission of Grand Prix
Sportique (Prints), Tetbury,
Gloucestershire.

Printed in Hong Kong
for David & Charles
Brunel House Newton Abbot Devon

CONTENTS

THE PAINTINGS

ACKNOWLEDGEMENTS

Thanks are due to the following who have kindly allowed access to paintings in their collections:

HRH The Duke of Gloucester	'The Duke on Camden Bank'
The Hon William McAlpine	'The Navvies'
Mr B. Baker	'Evening Star at Haworth'
Mr & Mrs H. F. Bowern	'Duchess of Buccleuch at Shap Wells'
Mr K. H. Breare	'Mirfield's Jubilee'
Mr M. F. Chaytor	'Rocket at Rainhill'
Mr P. M. Cooper	'Foxhunter at Copley Hill'
Mr & Mrs J. Eckersley	'Leeds City Station'
Mr N. R. Gard	'Princess Elizabeth at Edge Hill'
Mr A. Jowett	'Snow Freight'
Mr P. Lowry	'Rain, Steam and Lamplight'
Mr D. Moorehouse	'A. H. Peppercorn on Shed'
National Railway Museum	'King George V'
Mr J. A. Powell	'Between Turns'
Mr D. Shillito	'The Long Drag'
Mr W. C. Stockdale	'9F at Consett'
Mr D. St John Thomas	'Ramsgate Station'

'King Richard III at Paddington', 'Winter on the Settle–Carlisle', 'A Day at Bovey Tracey', 'Lydgate Viaduct, Todmorden', 'Sunset at Nine Elms' and 'Day's Work Done' are in private collections.

Acknowledgement is also due to the following:

71000 Steam Locomotive Trust who have allowed us to reproduce the painting 'The Duke on Camden Bank' which they published as a limited edition print.

6024 Preservation Society who allowed us to reproduce the painting 'Dainton Conquered' which they have published as a limited edition print.

FOREWORD

As current Chairman of the Guild of Railway Artists, I know that the Guild owes a great deal to Alan Fearnley, our previous chairman. Much of our success can be attributed to the quiet, always pleasant and modest, but direct guidance he gave to the Guild during its formative years. On behalf of the members, may I take this opportunity of thanking him.

All good paintings should speak for themselves, and I know of few that communicate more clearly or directly than those of Alan Fearnley. I'm not entirely sure it is wise to speculate on the reasons for this phenomenon, but clear in their message they are. Perhaps it is the appreciation of subtlety of form and colour, the wit and humour, the remarkable technical skill, or perhaps, the grand and highly individual treatment given to virtually any subject he chooses. I think the latter is closest to the truth. For of all these things, Alan's main achievement, for me, must be that rare and precious spark of originality with which he can communicate to his audience in a clear and no nonsense manner.

There are many competent artists, many technically clever artists, but Alan is one of only two or three I know who can claim to be a true original. As life becomes more mundane and repetitive, it is all the more important to treasure paintings such as Alan Fearnley's, whose work, and the breadth of subject matter encompassed by it, appeals to such a broad range of people. My two young daughters, Hannah and Claire, have been known to remark that a particularly spectacular sunset is an 'Alan Fearnley sky'.

Further words from me are unnecessary really, save for me to urge you to simply enjoy the highly original work of this singularly talented artist.

Sean Bolan GRA
Chairman of the Guild of Railway Artists

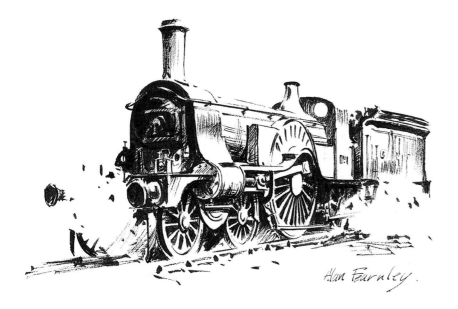

Alan Fearnley.

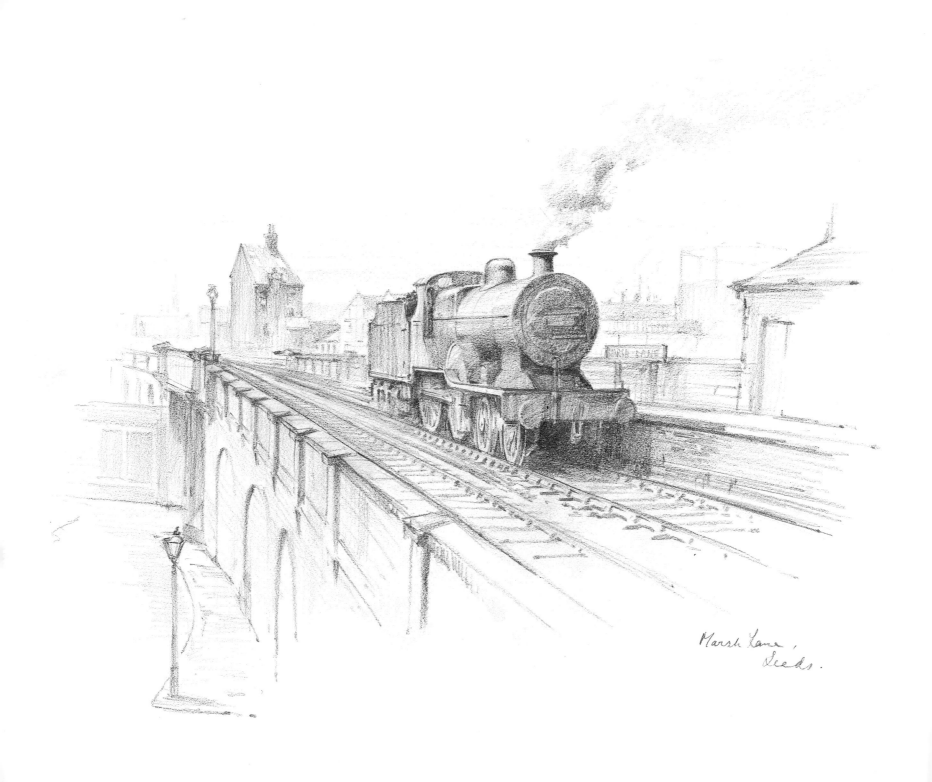

Marsh Lane,
Leeds.

INTRODUCTION

Standing on a hillside above the River Worth between Haworth and Oxenhope one winter's day in the late 1970s, I filmed a double-headed Santa Special toiling up the line. Two 0-6-0 saddle-tank engines were providing the action at the front of the train, and what a splendid sight they made. Battling against both the steep incline and a strong, snow-laden wind, blowing down off the moors around Wuthering Heights, the two small locomotives filled the valley with a crescendo of swirling steam and reverberating sound. It was a scene which encapsulated many of the elements that make the steam railway such a compelling subject for an artist, the dynamic vigour of hard working engines merging with the natural elements to create a scene of quite awe-inspiring spectacle.

It would probably be more correct to describe myself as a committed watcher of steam engines rather than a true railway enthusiast. As it was on that cold winter's day my interest is almost entirely aesthetic, an enjoyment of, and delight in, the sounds and sight of steam locomotives, the colours and reflections cast in fleeting shapes and shadows of exhaust which defines the landscape and then evaporates around it. The feeling of weight and power and presence, even when a loco is stationary, simmering and glistening with condensation, or dulled with coal dust and oil.

Although the great locomotive engineers, the different companies and the history of the railway system do interest me, it was these abstract qualities that first brought home to me the pictorial depth in the railway subject and led me to seriously take up railway painting. In the years since then, they are the elements that, along with some social and historical aspects of railways, have been most influential in my pictures. Regrettably, the intricacies of signalling, rostering, marshalling, etc, and the hundreds of other more mundane functions that

are necessary to make the railway work, and without which the sights and sounds of inspiration would never appear, only interest me when they become part of a painting.

Early Years

My first conscious memory of steam trains is that of lying awake at night, as a very young child in the late forties, listening to the noise of traffic on the line a mile from our house. Mirfield, where I was born and still live, stands at the junction of four main lines. From Halifax and Huddersfield and the Calder valley woollen mills in the west, and from Wakefield and Leeds and the Yorkshire coal fields in the east. In those pre-Beeching days of my childhood there was also another line from Bradford, and Mirfield boasted two stations, passenger and goods, and a locomotive shed. The noise of the railway and the drifting trails of steam were an almost constant part of daily life, unnoticed for the most part. In the quiet of evening though, when there was so much less traffic on the roads and so much more on the railway, the sounds of shunting stock and locomotives that slipped time after time before getting their trains under way was very clear, and is a childhood memory which will stay with me always. We now live much nearer to the line and it is the sound of Class 46 diesels rumbling through Mirfield with their trains of oil tankers that disturbs the night. I wonder if those sounds will be as evocative for my own two sons in years to come as the remembered sounds of steam-hauled coal trains are for me?

Collecting engine numbers was never a great preoccupation of mine, although I did spend a certain amount of time sitting on the wooden fence opposite Mirfield shed, armed with exercise book and pencil stub, close to the location of the painting

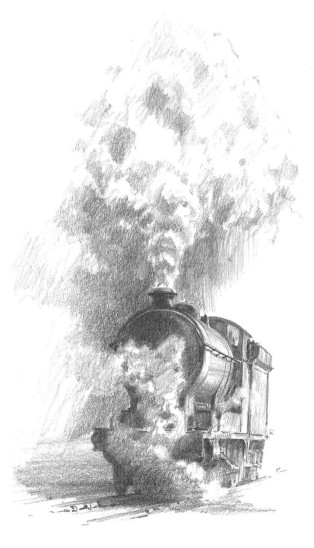

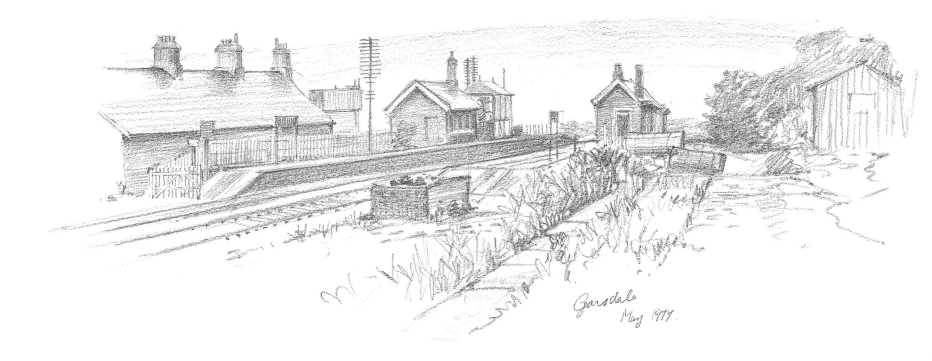

Garsdale
May 1977.

of 'Mirfield's Jubilee' on page 51. An Ian Allan book, in which the more professional train spotter can cross out or tick off those numbers bagged, never became part of my equipment, even if they were invented then, and the scraps of paper my numbers were jotted on always seemed to get lost so that the whole procedure seemed a bit pointless to me.

However, one point that does stick in my memory is that there did not seem to be any coloured engines at Mirfield. That is to say, coloured in the sense of being red, or green, or blue. Apologies to the maintenance staff who worked in the shed then, if this narrative maligns them, but, to my recollection all the engines operating in the entire Mirfield area were a uniform shade of rusty soot! The few times that I went to the sheds, or the many occasions watching from the lineside, or when we kids would run to a bridge and lean over the parapet to get covered in dirty smoke and steam, I don't ever remember seeing one of those brightly coloured 'foreign' engines that appeared in books, or on the posters at Mirfield station.

After leaving school in 1957 I always worked as an artist of some description, although the first job, hand-colouring photographs, was taken only as a temporary measure until my talents as a tenor saxophonist took the jazz world by storm. Fortunately for music lovers and our neighbours at the time, painting became gradually more important, and eventually took up all the hours previously spent practising improvisation on the saxophone. It was also around this time that my one short encounter with an art college took place, the same one, incidentally, now attended on a full-time basis by my youngest son, Lee. The junior artists at the photographic company were all required to attend an art college on day release from work and for evening classes, but, perhaps because of lack of

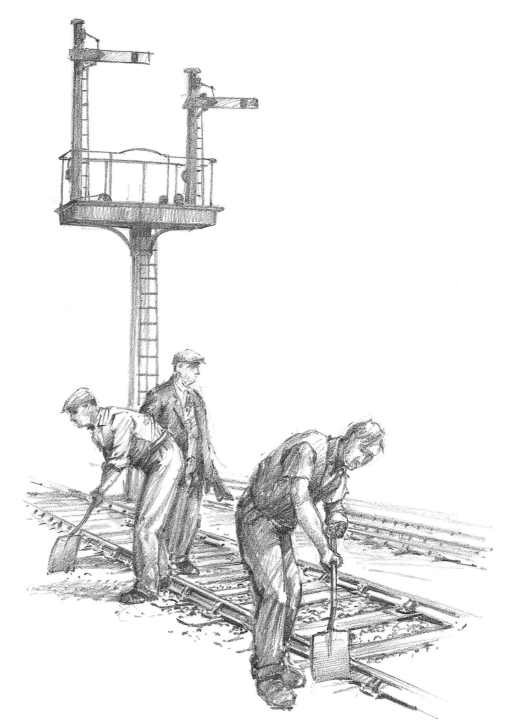

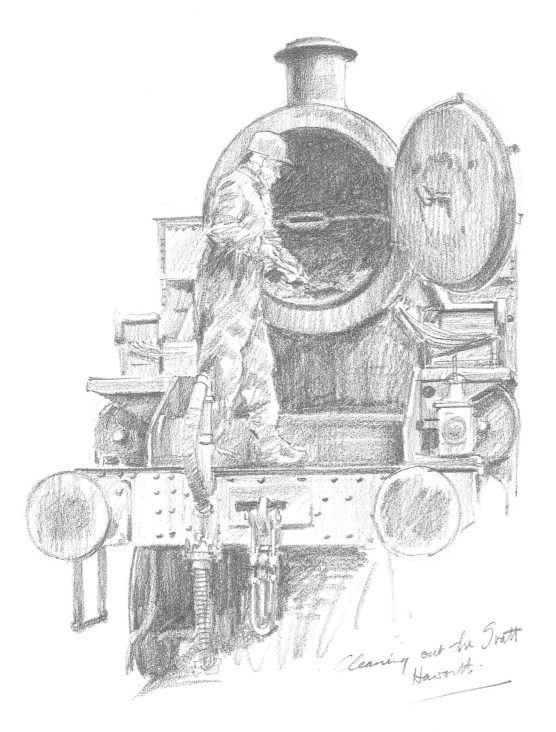

Cleaning out the Ivatt
Haworth.

commitment to painting at the time, or perhaps because I seemed to disagree with most of the opinions of the tutor, the whole business seemed a waste of valuable saxophone playing time. Consequently, along with one or two fellow students, as much time was spent at the cinema, or in a local pub with an easy going attitude to the age of its customers', as was spent at the classes!

It was only in later years when painting became a serious occupation that I realised how much had been learned, even in those few hours that were spent at college, and rather regretted not having had a more conscientious frame of mind.

First Paintings

My first paintings which included railway features were completed in the mid 1960s, but in a very different style to that which appears in this book and amounted to no more than the depiction of railway architecture around Mirfield, with perhaps a suggestion of smoke to imply the presence of a locomotive. Those pictures were very impressionistic, semi-abstract works, with the images built up in small dabs of colour, the important elements being shapes and colour, rather than detail or the realism of a captured moment. After a few years, however, this technique became less than satisfying requiring as it does, little in the way of actual painting skill and I found myself involuntarily turning towards a more illustrative style. My choice of subject matter also changed, away from topographical and landscape compositions towards transport oriented mechanical subjects, expressed at first in motor racing scenes, motor sport having been my one and only sporting interest for as long as I can remember.

Having done numerous motoring and marine

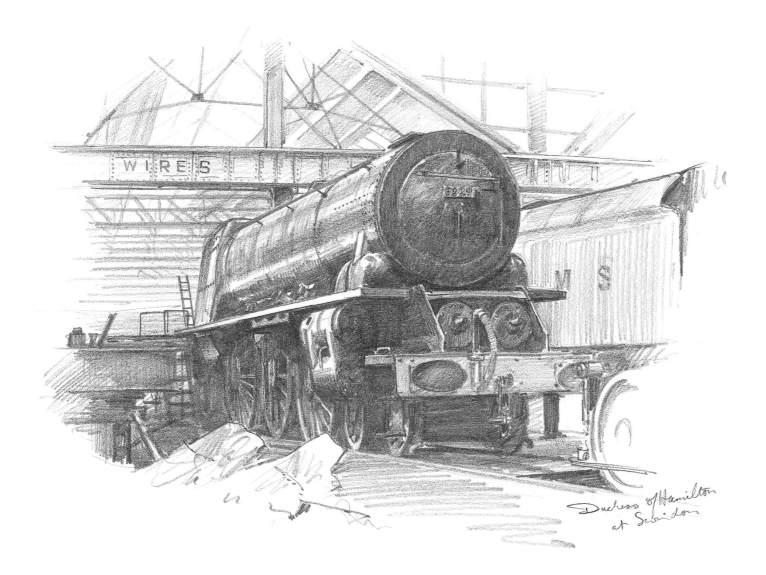

WIRES

Duchess of Hamilton
at Swindon

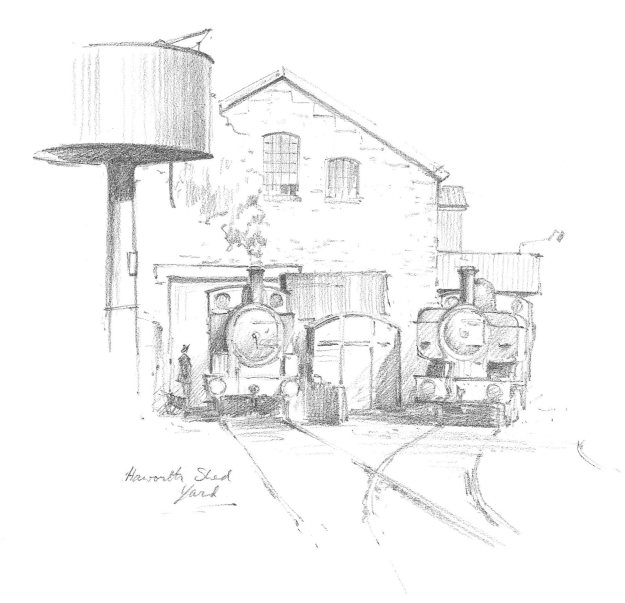

Haworth Shed Yard

paintings, the opportunity to paint a genuine railway picture was offered to me by a fellow artist in one of those unexpected twists of fate which often seem to change and redirect our lives. A friend, who worked alongside me as an illustrator in the studio of a greeting card publisher, had been invited to paint railway subjects for the owner of a local gallery situated in Keighley, who obviously hoped to benefit from the newly established Keighley & Worth Valley Railway Preservation Society. Malcolm Moore, the friend in question, is a fine artist and an exceptional draughtsman in a representational sense, but at the time was deeply involved in producing abstract work. His method of doing this was to draw designs or shapes on a piece of card with an oil can, and inks and water colour would then be splashed or painted onto the design and were consequently repelled by the oil into strange and haphazard swirls and hues and blotches of colour. He had acquired considerable skill and some very impressive results with what would at first appear to be a rather unstable technique. It was fairly obvious, however, that he would have problems using it to achieve a recognisable likeness of a Duchess or a Black Five. He therefore, generously passed on to me the gallery's invitation for steam locomotive paintings.

The only railway paintings familiar to me at that time were those by Terence Cuneo, and I had long been an admirer of his work. Besides being generally respected, Cuneo is very much an artist's artist and his technique, the vigour and deftness with which he applies the paint, is quite amazing. The idea of attempting work in a similar vein immediately appealed to me and I jumped at the opportunity offered. Steam reference was readily available at Haworth on the KWVR, already familiar to me through occasional Sunday mornings spent there with my two sons. And before long my

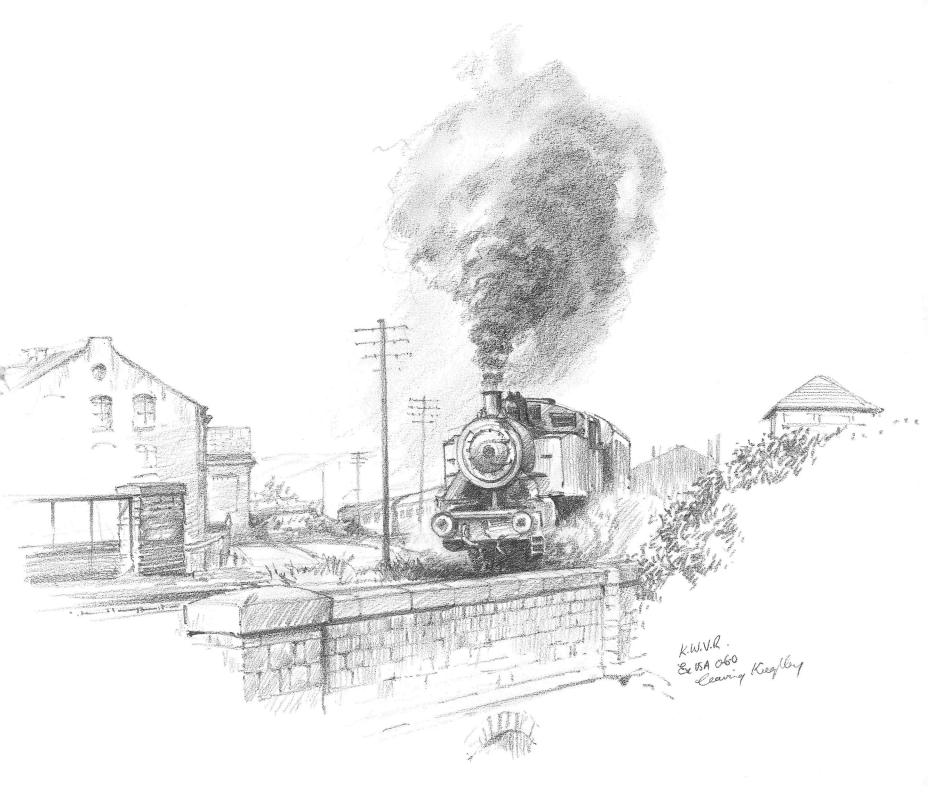

K.W.V.R.
Ex USA 060
leaving Keighley

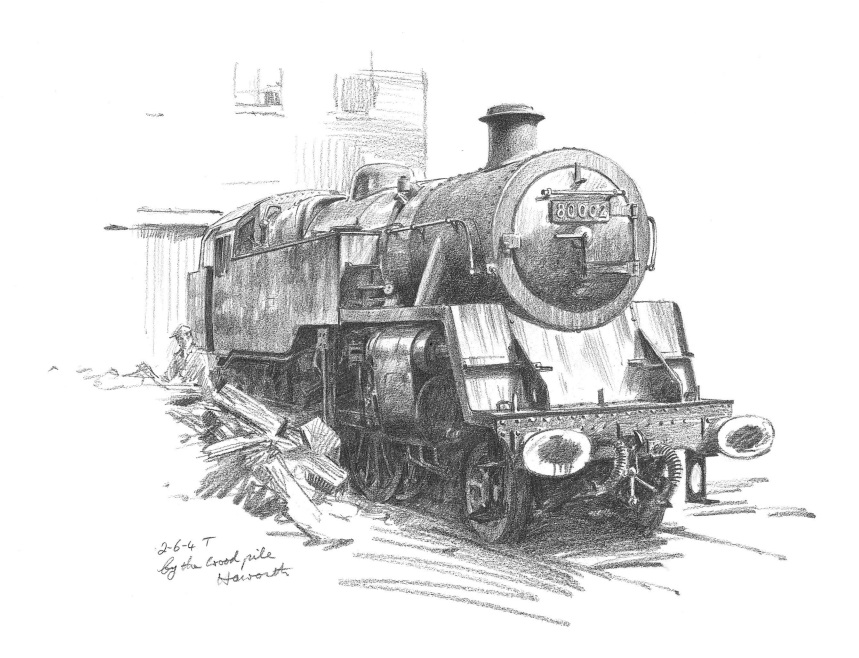

2-6-4 T
by the wood pile
Haworth

first real railway painting of 80002 outside the shed in Haworth yard was completed with the same composition and viewpoint seen in 'Evening Star at Haworth' on page 77. The picture was delivered and sold almost immediately, albeit for the sort of amount I would now expect to pay for a bare canvas. But no matter, my enthusiasm for railway painting had been kindled and a steady flow of railway pictures left my studio. Some, it has to be admitted, with embarrassing little mistakes on them before I started to catch up with the knowledge required for the work.

Another bonus of Malcolm's generosity was that I met David Wilkin, the gallery owner who had first asked for railway paintings and who has been a friend as well as my frame maker ever since.

My work progressed quite rapidly after that and all through the seventies, particularly after becoming a full freelance artist in 1974. Whereas previously my oil paintings of railways, or any other subject, had been confined to evenings and weekends, after that date I was able to take on enough commercial illustration to provide a basic standard of living and devote the rest of my time to the more important and interesting aspects of work. Slowly but surely, over the following years, as my name became more widely known, oil painting gradually replaced the more mundane illustration work.

As my output grew, of necessity, so did the areas in which paintings were exhibited and sold. They were also reproduced in one or two railway magazines, although this took place whilst I was still working in a studio and was again thanks to the efforts of one of the many friends with which my life has been blessed. Donald Mortimer was a sales manager with the same company and after looking through my copy of *Trains and Railways*, a long since vanished magazine which at that time was publishing a series of Cuneo's paintings, he asked

'Big Fred' Haworth

me why mine were not featured in the same way. I pointed out to him that this was *the* Terence Cuneo, a name spoken in hushed and revered tones in railway painting circles everywhere, and that the same thing could not be expected of a mere upstart like myself!

One evening a few days later Donald called at my house and announced that he wished to borrow a painting for a few days and that I was not to worry about it. 'That will do,' he said, indicating a recently completed picture of the Britannia *Royal Star* on Swindon shed. To my amazement, after a couple of days he returned from his sales trip to London with the news that the painting had been left at the office of *Trains and Railways* and that they were to publish it as a centre page spread.

Seeing my pictures published still gives me a thrill, at least it does when they are well reproduced, but I doubt if any other publication will ever give me the same sense of pleasure and pride felt when 'my issue' of *Trains and Railways* appeared on the stands. It also convinced me of a fact that I still believe to be true – that one of the greatest assets any artist can have is the friendship of a really good salesman!

Eric Treacy

It was in 1976 that I met Eric Treacy, one of the most famous railway photographers ever, who was then still the Bishop of Wakefield, earning for himself the title of The Railway Bishop. He had the sort of warm outgoing personality which after a first meeting left most people with the impression that they had been friends for years. This was certainly how I thought of him in the two short years before his death. We met at the National Railway Museum, where three of my paintings were included in an exhibition being held in connection

with the celebrations for the Settle–Carlisle centenary and Eric was speaking at the opening ceremony. We chatted and almost immediately he asked if I would accept a commission for a painting based on one of his photographs. Needless to say, there was no hesitation on my part, although normally, producing a painting directly from someone else's photographs is a pet-hate of mine and the three pictures that he eventually commissioned are the only examples of my work which I can remember painting in that way. Even in those three, small alterations and additions were made so that they would have some elements of my own individuality in them.

When a few weeks later he arranged to call and discuss the first painting, which was to be 'Duchess of Buccleuch at Shap Wells' (page 65), Sandra, my wife, was a little apprehensive, thinking of him as the Lord Bishop of Wakefield rather than another railway enthusiast, the role in which he was visiting us. However, when she brought coffee up to us in the studio and found the Lord Bishop sitting crosslegged on the floor rummaging through sketch pads and canvases, her anxieties were soon dispelled. That first painting also became my first limited edition print, signed by both Eric and myself. When it was suggested that he, as the photographer of the original, should also sign and that we should share the proceeds, he readily agreed, 'If you think anyone will be interested in my signature,' but, typically, he refused to accept any part of the commission payment. The print was signed on 5 April 1978 at the beautiful cottage in the Lake District to which he and Mrs Treacy had by then retired. As is well known, of course, he died a few weeks later, whilst photographing a steam-hauled special on the Settle–Carlisle line.

His death was a sad loss. To my mind he was not the greatest of railway photographers, being, with

the exception of several of his studies which are quite stunning, a superb recorder of the railway scene, rather than an artistic interpreter of it in the manner of such people as Colin Gifford. His contribution, through photography, to the world of railway enthusiasm however, made over a period spanning five decades, seems to me unlikely ever to be surpassed.

Guild of Railway Artists

One result of the publication of that first print was an invitation to join in the formation of a new art society, the Guild of Railway Artists. Subsequently at the inaugural exhibition of the Guild, held at the Guild Hall in York, I was honoured to be elected its first Chairman. An appointment which, having been made through the votes of fellow artists who, at the time, did not know me but only my work, was all the more gratifying. It was a position I was pleased to hold for almost five years.

The Guild of Railway Artists is unusual and probably unique amongst nationally organised art societies in its formation and the way it evolved. It is administered by, and was the creation of, two railway enthusiasts, Frank Hodges and Steve Johnson and it was born as the result of an exhibition of railway paintings organised by them in the Queen's Silver Jubilee year. Encouraged by the success of that first exhibition they decided to contact all the railway artists whose names they knew, in order to assess the potential support to the forming of a national society and the GRA was subsequently brought into being.

As with any society, the Guild has its faults and weaknesses but they are far outweighed by its strengths and values, and in its relatively short history it has achieved some outstanding successes, both as an exhibiting body and in publications it has

been involved with. Certainly my own development and career would have been markedly different without the influence of other Guild members and the exposure which my work and name received under the Guild's auspices. Along with the hundred or so other members I am indebted to Frank and Steve for their vision which led to the creation of the GRA, an art society that exists, apart from the countless hours of voluntary work they put into it, purely as a result of their enthusiasm for railways and railway paintings.

The Working Day

The working day starts for me around 8am. To many people, who imagine an artist's life as one of relaxation and indolence while waiting for the spark of inspiration to strike, this probably seems an unusually early hour. In my case, the choice of eight o'clock is due to many years of necessity and habit which have now resulted in a feeling of guilt if work is not progressing in the studio by 8.15am at the latest. The necessity came about through both the studios in which I worked before becoming free-lance, starting their working day at eight rather than the more normal nine to five associated with an office environment. The habit came about when, having turned freelance, the opportunity to escape the daily trauma of late breakfast, lost PE shorts, undone homework and forgotten-to-be-cleaned shoes that always seems to surround getting two boys off to school was offered by sneaking up to the studio for an early start.

At lunchtime, or sometimes during the day if work is not going well, I take our golden retriever for a walk, usually through the woods and around the local golf course or along the canal tow path if the weather is wet. During these daily walks it is easy to relax and problems and ideas often resolve

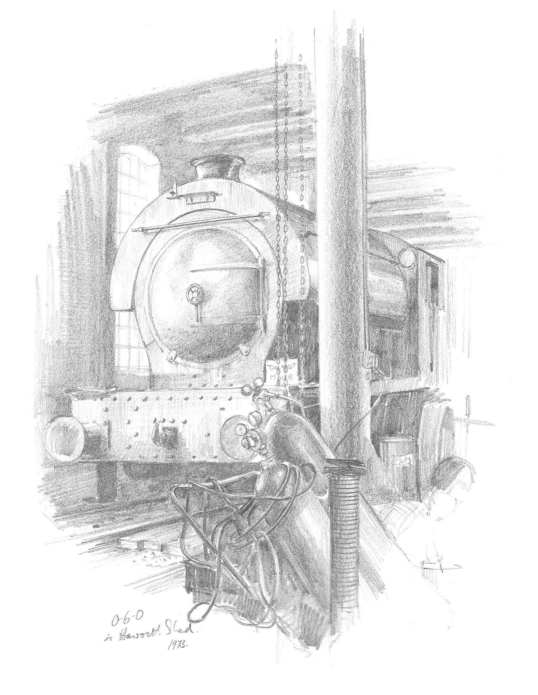

0-6-0
in Haworth Shed.
1973.

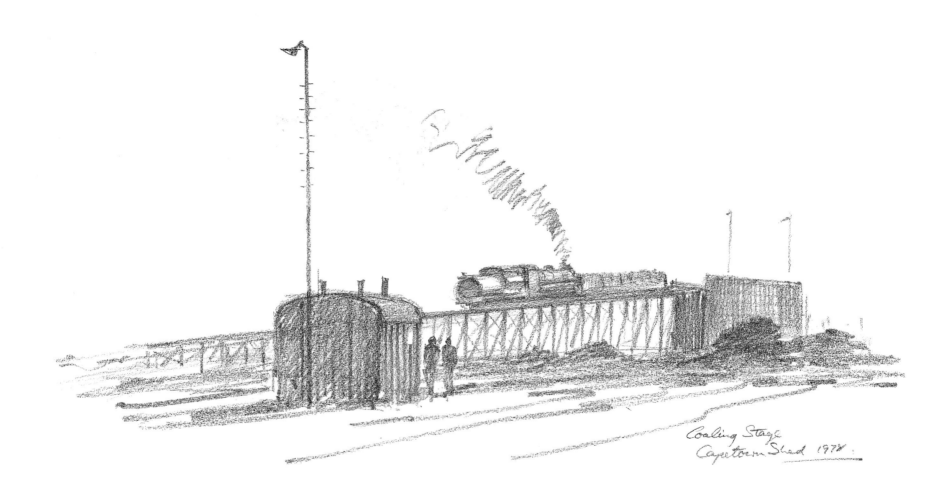

Coaling Stage
Capetown Shed 1978.

themselves into solutions and decisions much more easily than whilst working in the confines of a studio. A little earlier I mentioned the word inspiration. Although I do believe that inspiration occasionally does strike, it is certainly not on such a regular basis that it can, in any way, be relied upon. In my case, the origination of paintings, and decisions made during the painting process, are the results of these periods of quiet reflection and the continuous jotting down of ideas until what appears to be the right one emerges.

My afternoon session extends only until about 4.30pm, but almost invariably work starts again during the evening for another couple of hours or so and the working week also extends over the weekend in an intermittent fashion of occasional hours and stops and starts. This illustrates both the advantages and disadvantages of having a studio at home. It is easy to carry on painting or to get quickly back to work if a picture is going particularly well or is required urgently, or, for that matter, if it is a typically dull evening's entertainment being shown on television or too wet a weekend to spend in the garden. On the other hand, my work is so accessible that it is often difficult to get away from it and relax or make time for other interests which might provide a foil to my work as an artist.

That work, of course, appears to many people to be already relaxed and sedate, due, probably, to the fact that most people who take up painting do so as a form of relaxation rather than a means of earning a living. However, it is very rare for a painting to progress smoothly from start to finish and the need to surmount the new problems which arise with each new picture does, at times, lead to a considerable amount of stress. At least, it is a fact that on becoming a freelance artist I had a full head of dark hair, whilst now, what little I have left, is rapidly

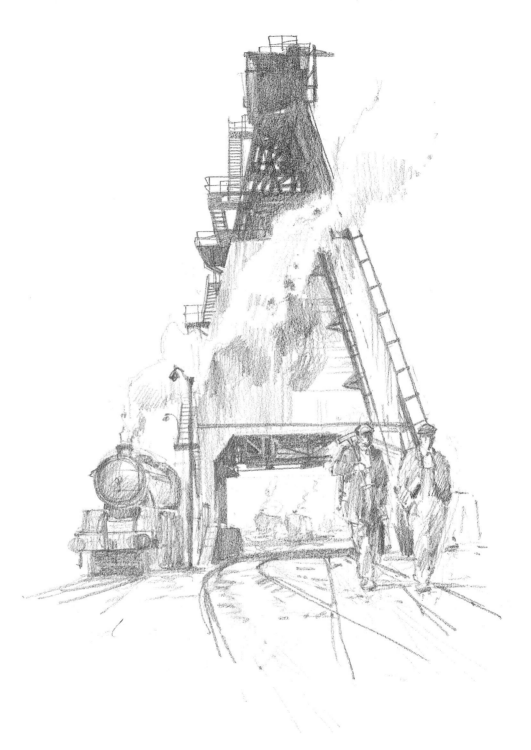

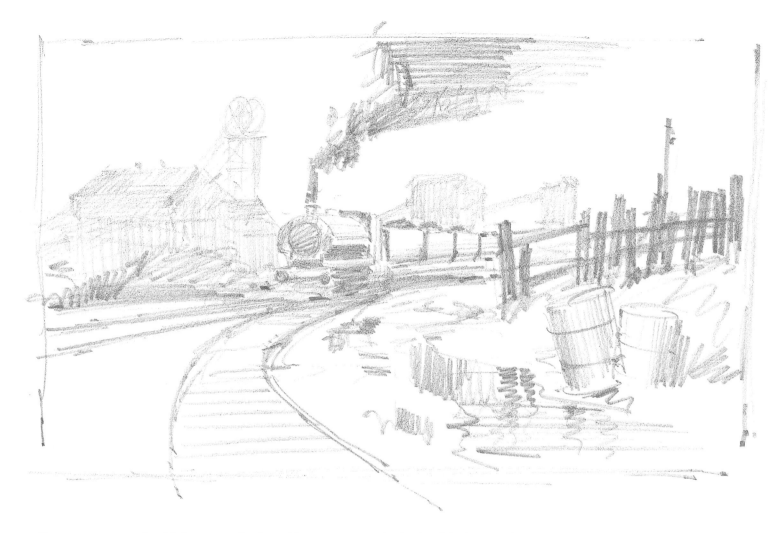

turning grey. To compensate me for this loss, one of the greatest benefits of working as an artist, apart from spending one's life doing what one most enjoys, is the amount of freedom that the lifestyle affords. That freedom is perhaps illusory, or for the most part unused, as almost every day is spent working anyway, but the knowledge that the freedom is there, to have the choice to work if and when I want or to be able to make the most of weather or seasons or events, is something to which I attach a great value.

Some railway artist friends choose to paint nothing other than railway subjects, a commitment I would not want to make having felt the need for a change of subject whenever my work has called for a series of paintings on one theme.

Whilst railway painting has been very important to me, particularly in the seventies when it comprised the major part of my output, I consider myself to have been fortunate in the variety of other commissions that have come along. Over the years that variety has extended from the occasional portrait to portraying a nuclear power station under construction, from nineteenth-century clipper ships to formula one racing cars and from sporting events to scenes of military battles. Along with the variety of paintings there has been the bonus of meeting and being briefed by those people involved in the subjects, for instance a World War II general or a world champion racing driver. There are also, what are for me, the occasional unusual experiences. When commissioned to paint a picture of a radio controlled aerial target, it was necessary to spend a day at sea on board a Royal Navy RFA. As well as testing the target they also refuelled two frigates, all of which happened whilst ploughing into a force five gale and provided an amazing spectacle. These are just a few of the examples of the interest and variety which have been the result of choosing to

work on a broader canvas than that offered by railway art alone.

Often lessons learnt or ideas tried out in one area of painting can be successfully transferred to another. Some years ago I exhibited with the Guild of Aviation Artists a picture of Spitfires in a hangar. The effect aimed for, and apparently achieved, was that of a typical loco shed with shafts of light filtering through the skylights and casting shadow patterns on, in this case, the aircraft below. The source of the idea must have been very obvious as, at the exhibition preview, one of the other artists nudged me and asked with a grin, whether they were LMS or GWR Spitfires in the picture.

The Painting Method

My method of working follows a broadly similar pattern with every painting, although of course each differs in certain aspects. Firstly the canvas is covered with a ground colour, which is usually a warm ochre shade. The ground colour ensures an overall tonal harmony to the picture as colours which do not harmonise clash with the background. The choice of the ochre colour is also the main factor that accounts for the warm tones of most of my paintings. The amount of detail in the initial drawing on the canvas depends on the complexity of the subject and composition. For instance, in the case of a locomotive drawn large in the picture area and consequently highly detailed such as 'Foxhunter at Copley Hill' on page 45, or in a complicated figure composition where the relationship of the groups to each other is important such as 'Rocket at Rainhill' or 'The Navvies' on pages 47 and 53, then I will produce, to my complete satisfaction, a full sized, detailed drawing on tracing paper before transferring it onto the canvas. When a picture involves objects that are less prominent or

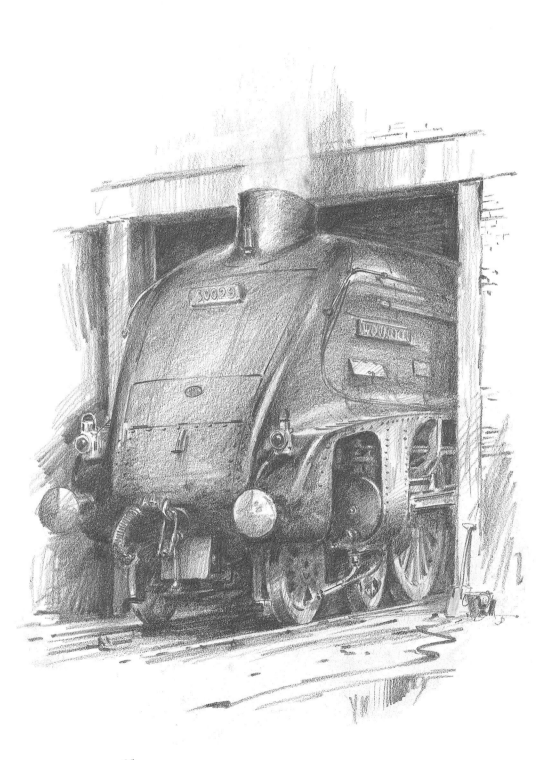

more simple in shape, or when the main picture area is made up of landscape as in 'The Long Drag' or 'Day's Work Done' on pages 63 and 79, then I simply suggest the composition on the canvas with a few pencil lines or brush strokes and do the drawing with the brush during painting.

The first of these methods produces paintings that are very accurate but often lack spontaneity and have a rather stiff and over-careful appearance, whilst the second, although achieving pictures which are fresher and more loosely painted, sometimes give problems with the meticulous detail that many enthusiasts like to see. My attitude towards accuracy in paintings is perhaps more flexible than it ought to be, but I have a firm belief that the painting and the artistic interpretation involved in it is more important than the subject being portrayed. Consequently, whilst such items as locomotives, major stations etc always require to be accurately treated, the laws of artistic licence can quite legitimately be applied to everything else. In views where our Lord got the horizon at the wrong level, or allowed trees to grow in most inconvenient places, I am quite happy to correct the landscape, or if the old industrialists didn't build enough mill chimneys to provide sufficient smoke and atmosphere, then the artist, for the sake of a painting, is quite at liberty to redesign that bit of our industrial heritage. In other words, having got the few essentials correct, as far as the rest of the picture is concerned, if it looks right, it is right!

If my method of painting varies very little, then it is in direct contrast to the variety of people who buy or commission paintings and their reasons for doing so. Many railway enthusiasts of course, want a painting portraying a particular locomotive or, more often, I find, a particular location. For instance, a view of Belle Isle for a man who train spotted there in the 1940s, or an A3 crossing the

viaduct at Durham with the cathedral in the background. According to Eric Treacy, that was a view which could only be seen from a position in mid-air and is consequently denied to photographers, but I painted it for a man who had been president of Durham University railway society and had also sung in the cathedral choir. An elderly lady once bought a picture of *Abbotsford* standing in York station. She had no interest in railways and I doubt if she knew that *Abbotsford* was either an A1 or a Pacific, but, I was told, the painting reminded her of her late husband and the many times they had met and said goodbye on the platforms at York.

In recent years I have been fortunate that most of my work has come in the form of commissioned pictures. This gives a guarantee of income of course, but can constrict the freedom of an artist, particularly if the patron gives too many instructions that cover every aspect of the painting. There is also a temptation for the artist to try and produce the painting that he knows the client is expecting and that will be a success, rather than attempt a fresh or new approach with its attendant element of risk and rejection.

Fingers crossed, although once or twice clients have asked me to make alterations to paintings, I have yet to have my first outright rejection. Consequently, because of the pressure to produce work to patrons' guide lines, between commissions it is almost a relaxation to be able to work on pictures of my own choice, perhaps adopting a slightly different approach or technique.

Enthusiasm v Art

One of the main problems facing the railway artist who wishes his or her work to be recognised by the art world in general is to be able to dissociate the portrayal of an enthusiasm from the creation of a

work of art. This is in common with all the subjects which make up what might be termed the enthusiast school of painting, ie railway, aviation and motoring art. In general, and I admit that it is a generalisation, pictures produced in this school have an appeal, or hold interest only for people who are themselves enthusiasts of that particular subject and are largely ignored by critics and the art establishment. This is a rule that does not seem to apply to marine painting and I think there are two reasons why that should be the case. Firstly, marine painting has a much longer history and is consequently a long established and recognised school of art in itself but, more importantly, it is of necessity,

as concerned with the elements of sky and sea and weather, as it is with ships, encouraging the aesthetic qualities which are so important in a work of art.

Many of my fellow artists, of course, disagree with these views and do not see their commitment to their enthusiasm as a hindrance to their artistic development, being content to paint portraits of locomotives or cars. Over recent years though, I have become convinced that if the enthusiast school is ever to become recognised and valued in the art world, achieving equality with marine painting, landscape and portraiture etc, it is necessary that it should produce pictures with an artistic quality that

can be appreciated and valued by all art lovers and not one that is obscured behind a subject which is only of interest to a fellow enthusiast. After all, one does not have to be a Cape Horner to appreciate a good seascape or a committed fell walker to have a mountain landscape hung over the sideboard, but few people, other than 'dyed in the wool' enthusiasts, could live with a picture of a Black Five on Shed!

A more practical problem in broadening the scope of enthusiast art is, of course, the fact that we artists depend to a large extent for our livelihood on the picture-buying enthusiast, who very often wants precisely the type of painting which will remain artistically unrecognised by the rest of the art world.

It may be that these thoughts are really irrelevant, and with a subject matter as strong as that of railways, it would be impossible to produce 'a number of paintings which the non-enthusiast public could view and appreciate simply as works of art. If that is so, then the railway artist will never be more than an appendage to the mainstream of railway enthusiasm and there are many of those artists who would consider that no bad thing. After all, I must admit to having been happy to paint my own portraits of locomotives and to having been, for the most part, satisfied with the results, and grateful for the professional success and personal associations which railway painting has brought. But really, I do believe that if the enthusiast school of painting could detach itself from the constraints of its own enthusiasm and begin to explore its social and historical aspects and the elements and landscapes surrounding its central themes, it could become more fulfilling for both artist and patron, and also gain a place amongst the already recognised art movements.

Waggon at Carnforth
July 77

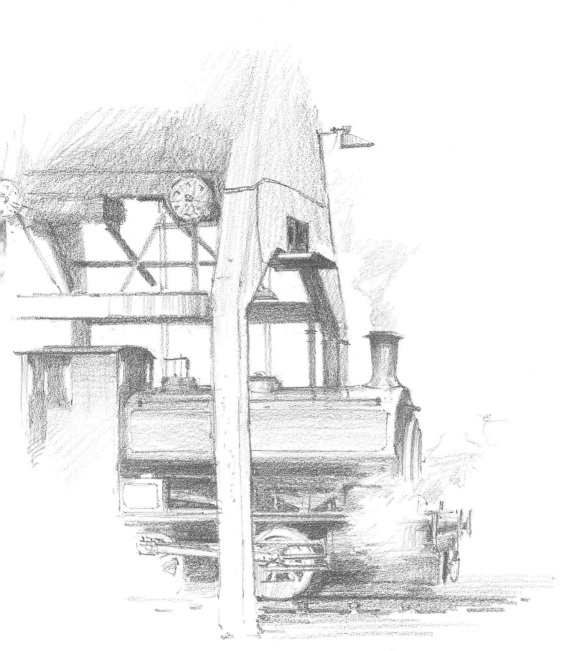

0-4-0T
Carnforth

After laying out the composition on the primed canvas with fairly bold brush strokes, the main elements of the picture are painted in to a reasonably finished standard. These are then brought together as the background, sky and trees etc, are painted in, and, in the case of this painting, small errors of perspective are corrected. When the canvas is entirely covered the final detail work is completed and the balance of colours adjusted where necessary.

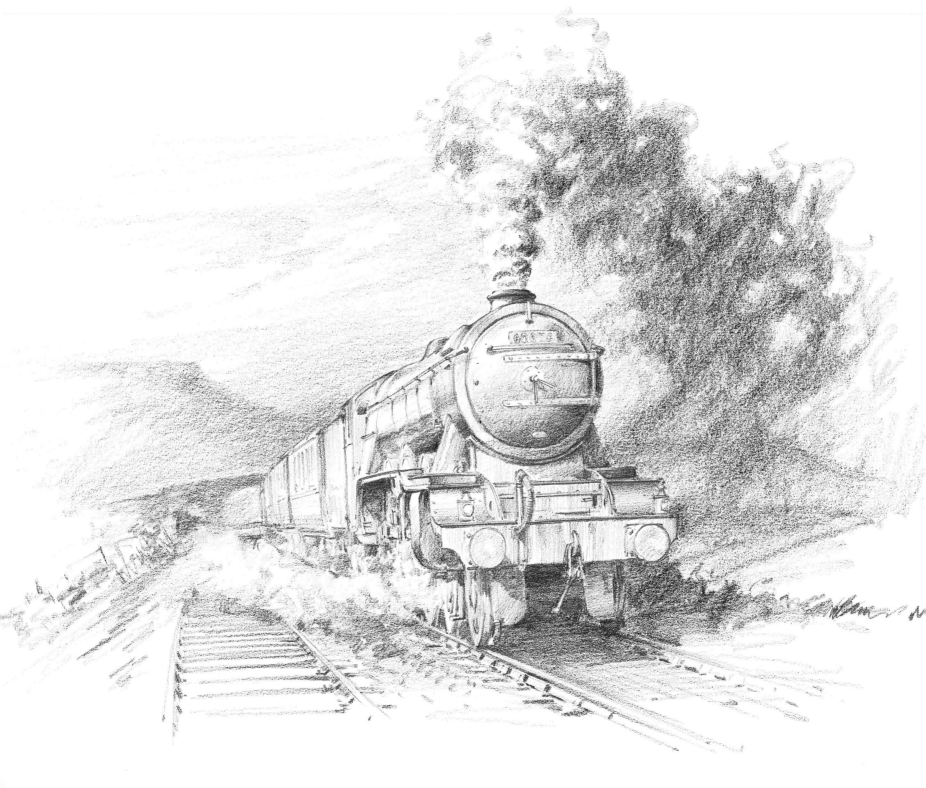

THE PAINTINGS

A. H. PEPPERCORN ON SHED
36″×24″ Oil on Canvas

Class A2 Pacific No 525 is seen here on the turntable at York MPD, soon after being built at Doncaster. No 525 was, in fact, virtually the last locomotive completed by the old LNER company, having come into service just before nationalisation in December 1947. As it was the first of his class of A2 Pacifics, the engine was also given the name of the newly appointed chief mechanical engineer of the LNER, Mr A. H. Peppercorn, although the design had actually originated under his predecessor, Edward Thompson.

In railway painting it is relatively easy to achieve 'atmosphere' in a composition. Atmosphere, in this case, referring to an elusive, almost indefinable quality, that a fellow artist once summed up very simply to me as 'that little bit of magic'. Steam locomotives, particularly when stationary, wreathed in wisps of exhaust and eddies of steam from leaky valves and cylinders, seem to carry their own atmosphere with them. Nowhere is this more evident than in an engine shed or round-house, where light filtering through the smoke-darkened windows casts webs of shadow over the assembled engines and masks the oil and the grime. The resultant atmospheric, almost cathedral-like, effect has provided an irresistible source of subject matter for virtually all railway artists and photographers, and, if tackled with any technical ability at all, almost guarantees an attractive result.

The scene in my painting still exists, although in a much altered form and entirely devoid of the atmosphere of days gone by. It is now the main exhibition concourse of the National Railway Museum, and is host to many locomotives which would have been foreigners here in Mr Peppercorn's day.

The LNER 4-6-2 Class A2 locomotives numbered fifteen in all, and were built at Doncaster, with 6ft 2in driving wheels, between December 1947 and August 1948. No 60532 Blue Peter *was the last example to be withdrawn in December 1966 and has been preserved.*

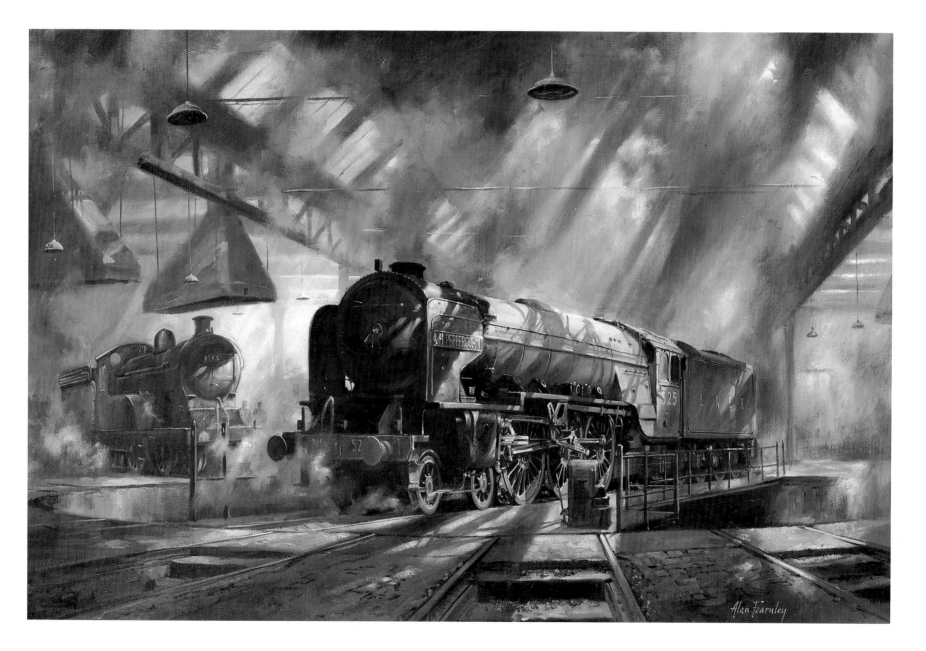

Alan Fearnley

DAINTON CONQUERED
36″×24″ Oil on Canvas

No 6024 *King Edward I*, one of the superb GW King class, though seen here in BR days, cresting Dainton Bank near Newton Abbot with the Royal Duchy. This painting was commissioned by the 6024 Preservation Society in order to publish a limited edition print to help in the raising of funds for the restoration of the locomotive. The society was quite specific in its instructions for the work in such items as livery, coaching stock, headboard and location etc, but an interesting request was for a plume of steam at the safety valve. They obviously wanted to emphasise just how powerful these locomotives were.

The Kings were, of course, the final development of the Churchward/Collett four-cylinder 4-6-0s and, with their larger boilers and the heavier appearance of the front end, they lost the 'prettiness' common to so many Great Western locomotives. What they lost in elegance, however, was more than made up for by the impression of power which they gained, similar to that created by both the unstreamlined Coronations and the rebuilt Merchant Navy class. However, dare I say it, to my eye both the Southern and the LMS engines are more satisfactorily proportioned than the pride of the Great Western. Of course, this is only the view of a mere artist and does not relate to such things as engineering and performance, on which I wouldn't dare make any comment, and consequently, is not a view to be taken seriously by Great Western enthusiasts.

GWR 4-6-0 King class locomotives, numbering thirty in all were built at Swindon between 1927 and 1930, the final examples being withdrawn in December 1962. King George V *and* King Edward I *are both preserved.*

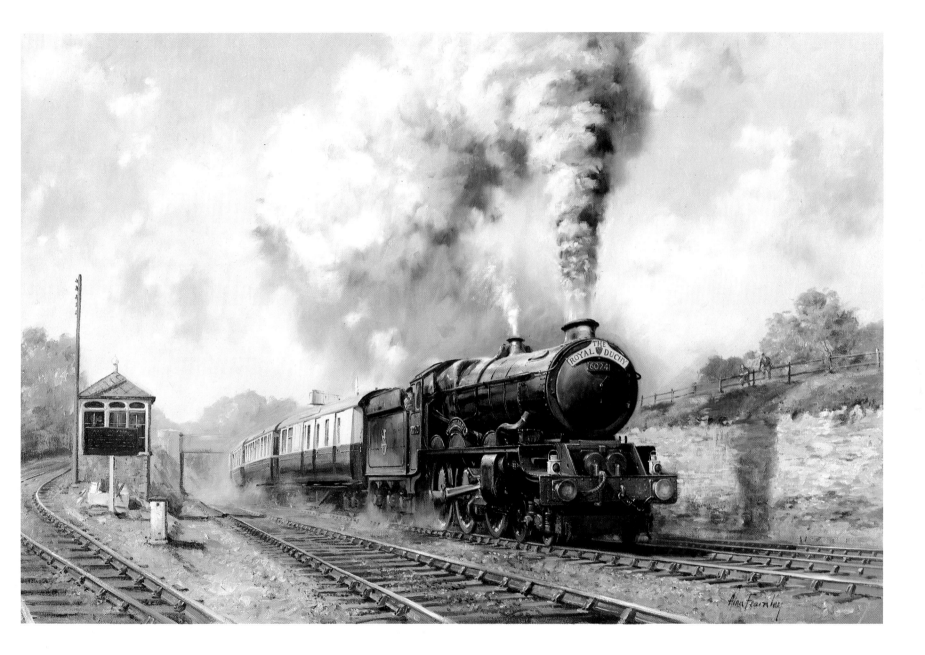

RAIN, STEAM AND LAMPLIGHT
30″×20″ Oil on Canvas

Coronation class No 6244 *King George VI* simmers in the evening drizzle waiting for its turn of duty. In common with many other people, I find the destreamlined Coronations the most visually attractive and impressive locomotives of the modern steam era in Britain. It is not the fact that they are so big, although their very size is impressive, but they have a perfection of proportion without the blandness which that sometimes gives. By some strange personal quirk I think they looked at their very best immediately after the streamlined casing was removed and the top of the smokebox was still angled backwards.

When *Duchess of Hamilton* was being rebuilt prior to going on display at the National Railway Museum, a friend and I went down to Swindon to see the engine and scrounge a look around the works. The big Pacific was looking a bit sorry for itself, still without cab, wheels or chimney and was in a bay next to an equally forlorn looking Western diesel. It seemed ironic that the attractive Westerns were on their way out of service, after such a short time, while here was a forty-year-old, obsolete steam engine being brought back to life!

LMS 4-6-2 Princess Coronation class more commonly known as 'Duchesses'. Designed under the direction of W. A. Stanier and built between 1937 and 1948 the class numbered thirty-eight examples of which twenty-four were originally streamlined. The last engine was withdrawn in October 1964. No 6235, No 6229 and No 6233 are preserved.

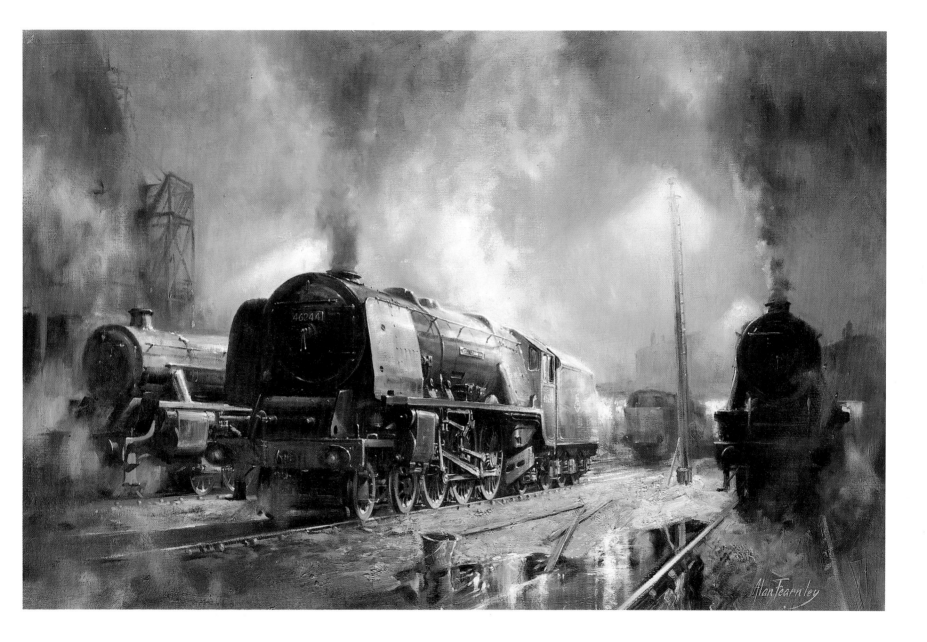

BETWEEN TURNS
20″×16″ Oil on Canvas

This is a small painting for which I have considerable fondness because of my enjoyment in attempting facial expression and an interaction between different types of character. Here we have a driver, benign and slightly rotund, with the impressive white whiskers that he might consider appropriate for a man of his position and experience, obviously amused at the latest yard gossip being passed on by an old fitter who looks after the odd jobs. The younger fireman lights up another cigarette and looks forward to a pint or two at the end of the day's shift. Behind them the driver's Thermos flask stands on the running plate of his 4-6-0 GWR Grange.

All that is, of course, make-believe and imagination on my part, but has resulted in a painting that, for me, holds more interest and fascination than many larger canvases portraying the purely mechanical aspect of railways. Hopefully, a small cameo such as this, will tell a great deal about the subject matter portrayed. The type, character and jobs of the men, the size of a steam locomotive and its class, and, through its condition and that of the yard, the likely period of railway history in which the scene is set.

The GWR Grange class 4-6-0 locomotives were built between 1936 and 1939 to the design of C. B. Collett and totalled seventy-nine engines. They were all withdrawn from service by the end of 1965 and none have been preserved.

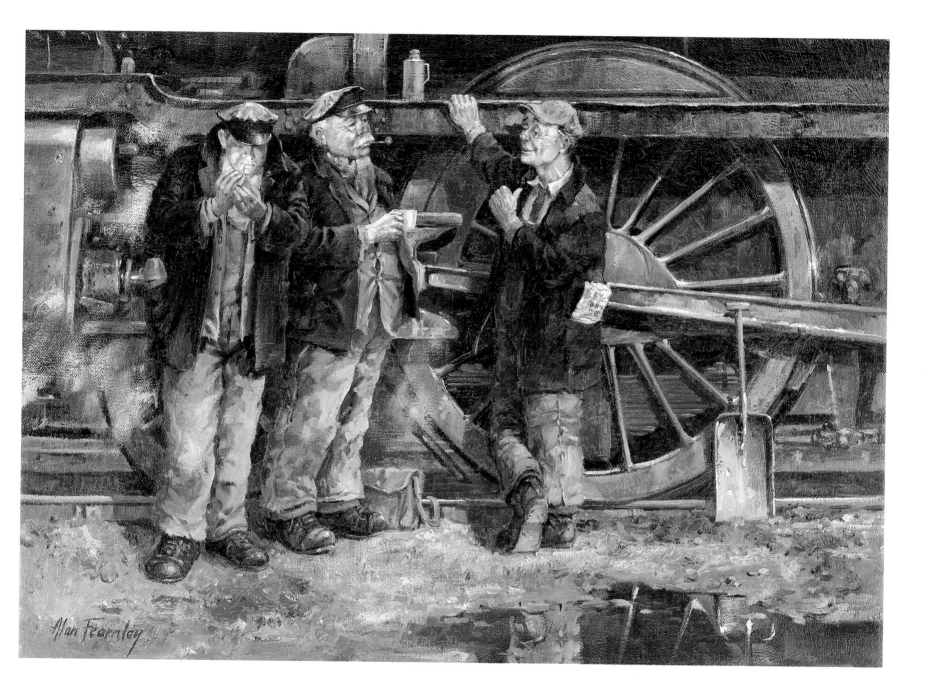
Alan Fearnley

COCK O' THE NORTH LEAVING KING'S CROSS
30″×24″ Oil on Canvas

A scene from the mid thirties when *Cock o' the North* was running in her original form as a Class P2, 2-8-2 locomotive. Only the first two engines of the class were built in this form with semi-streamlined smoke deflectors and cylinder casings, the remaining four locomotives being given a streamlined appearance similar to that of the A4 Pacifics. The designs were, of course, originated under the direction of Sir Nigel Gresley and in 1938 he had the first two engines rebuilt to conform with the later members of the class. The six 2-8-2s did not last very long however, and in the last years of World War II his successor, Edward Thompson, had them all rebuilt as rather awkward looking Pacifics and reclassified A2/2.

King's Cross is a rather dowdy and uninspiring building from the outside, particularly when compared to the magnificence of the Midland Railway's St Pancras station, just a few hundred yards up the road, the towers of which can be seen in the distance above *Cock o' the North*. From a painter's point of view, however, the business side of the station with the unusual gantries and walkways which existed during the steam era, has excellent pictorial qualities. On the right of the picture is one of around sixty N2 0-6-2 tank engines allocated to King's Cross and fitted with condensing equipment to allow them to run in the long tunnels to Moorgate.

LNER Class P2, three cylinder, 2-8-2 locomotives numbered a total of six in all, built at Doncaster in 1934–6. No 2001 Cock o' the North, *No 2002* Earl Marischal, *No 2003* Lord President, *No 2004* Mons Meg, *No 2005* Thane of Fife *and No 2006* Wolf of Badenoch. *All were rebuilt as A2/2 in 1943/4.*

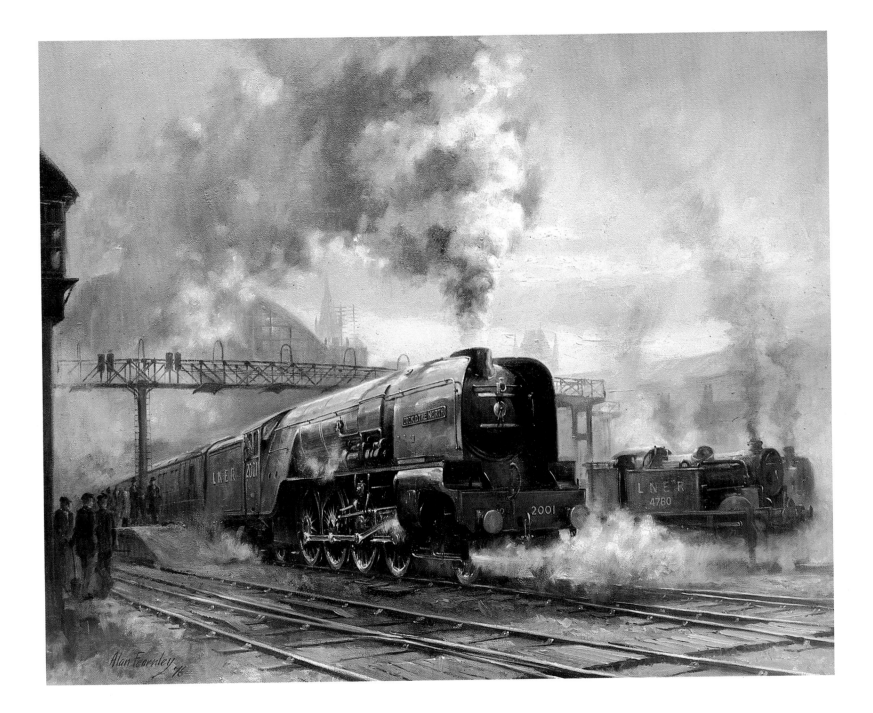

KING RICHARD III AT PADDINGTON
30″×24″ Oil on Canvas

South west coast expresses preparing to leave Paddington station on a bright summer's day in the 1930s. The days before motorways and almost universal car ownership, were, of course, the great days of the holiday expresses from the capital to the resorts of the south west, although I have not adorned the locomotives with head-boards in this picture, such trains as the Cornishman, the Cornish Riviera and the Torbay Express were in my mind when I painted it.

This painting has had, in fact, something of a chequered career. It was entered for a sale at one of the leading London auction houses, but between delivery there and the sale day it was involved in a fracas with a penny-farthing bicycle, which somehow managed to fall on it. Needless to say, my picture came off second best in this contest and was withdrawn from the sale with grievous injuries. However, the insurance payout was at least as much as I had been expecting from the sale so the outcome was not particularly unhappy for me. The picture was, I believe, eventually professionally repaired and sold at a subsequent auction.

Selling pictures through auction houses is a method I have used only occasionally, although it can be a convenient way of raising cash during hard times, it is an extremely 'hit or miss' way of making a living. There is some benefit to be gained from publicity in catalogues and at one particularly good sale a painting of mine sold for more than twice the expected amount, but in my limited experience it seems as likely that pictures will not reach their reserve, leaving the artist out of pocket through time and travelling expenses. It seems to me that, in spite of high commission charges, the traditional art gallery is still the artist's best method of getting his work into the public eye.

GWR 4-6-0 King class No 6015 King Richard III at Paddington *c1934. The Kings class locomotives, numbering thirty in all were built at Swindon between 1927 and 1930, the final examples being withdrawn in December 1962.* King George V *and* King Edward I *are both preserved.*

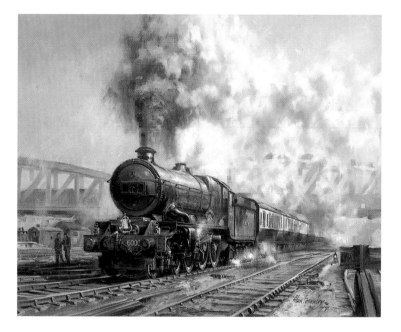

KING GEORGE V
30″×24″

No 6000, *King George V*, one of Britain's best known preserved locomotives, heading Westward soon after leaving Paddington Station, on the GWR's original main line to Bristol. This painting was one of those commissioned by Eric Tracey and is, of course, based closely on one of his photographs, although *King James I* was the locomotive he actually photographed. No 6000 is now normally kept at Bulmers railway centre at Hereford.

The GWR 4-6-0 King class locomotives numbered thirty in all and were built at Swindon between 1927 and 1930. No 6000 King George V *and No 6024* King Edward I *are preserved.*

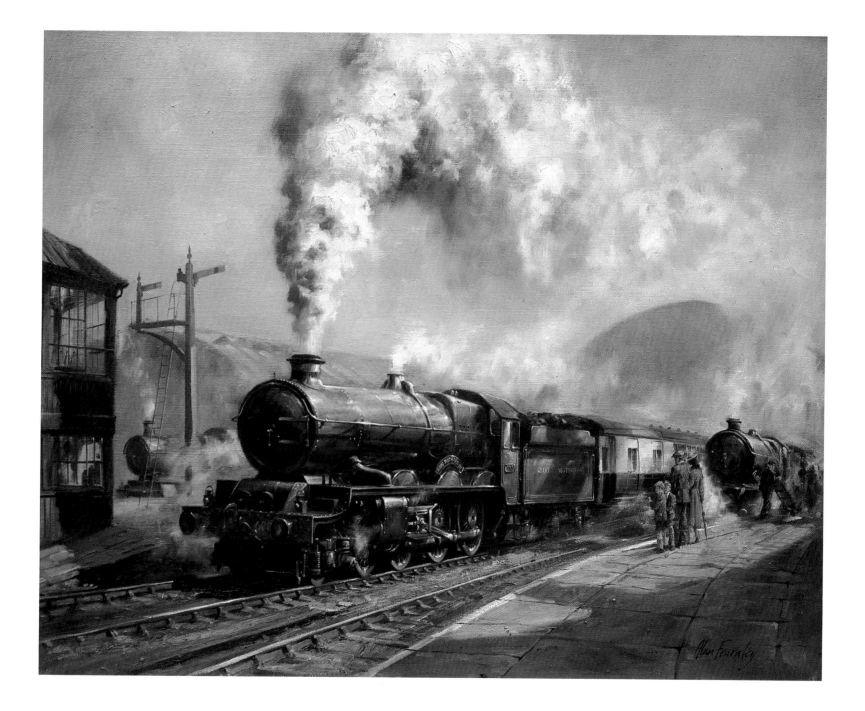

Alan Fearnley

FOXHUNTER AT COPLEY HILL
36"×24" Oil on Canvas

One of Sir Nigel Gresley's fine Al class Pacifics pictured on a damp and dismal day by the coaling plant at Copley Hill, which, along with the depot at Neville Hill, was mainly responsible for attending to the needs of Eastern region engines in the Leeds area. Some years ago, our main local newspaper, the *Yorkshire Post*, published a series of photographic booklets entitled *Yorkshire Steam* which provided excellent reference material for the railways and sheds in the Leeds area. As I have never been to Copley Hill it was from those books that the necessary information for the background of this picture was derived.

It is probably true to say that without photographic reference the emerging school of painters devoting their talents to the depiction of 'enthusiast' interests such as railways, aviation, motoring etc, would not exist. Over the years artists such as myself build up substantial libraries amounting to, in my case, many hundreds of books and magazines, along with boxes of loose photographs and in recent years, reference on video tape as well. This reference is essential, of course, if a picture is to be authentic but, in my opinion, should not be seen as something to be slavishly adhered to or simply copied in total. If that were the case the painting might as well be done over the top of the photograph. The artist must always impose his or her picture onto the reference, reorganising and making additions or deletions as necessary, using the reference as a starting point, or to add authenticity to an idea, but not allowing it to control or replace the idea itself.

The A1 4-6-2 locomotives were built under the direction of Mr A. H. Peppercorn at Doncaster during 1948 and 1949. They were very similar in appearance to the A2 Pacifics but had 6ft 8in driving wheels. A total of forty-nine were built, the last being withdrawn in 1966 and all the class were scrapped.

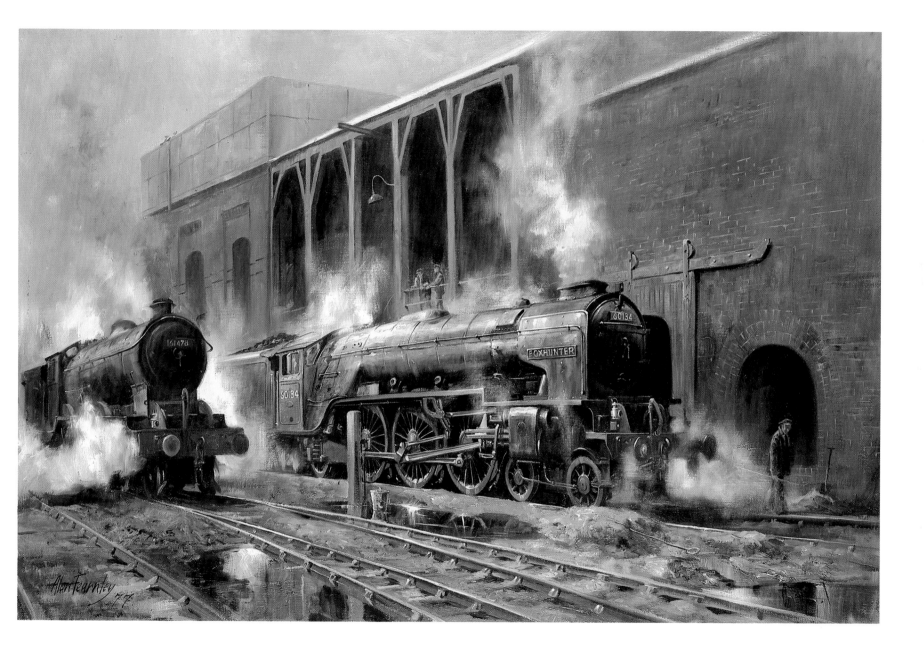

ROCKET AT RAINHILL
36″×28″ Oil on Canvas

Rocket, with Robert Stephenson at the controls, bursts under the skew bridge at Rainhill near St Helens. The occasion was, of course, the famous locomotive trials of 1829, used by the directors of the Liverpool and Manchester Rail-Road Company to choose a type of engine for their railway. *Rocket* won and was apparently easily superior to three of its four competitors, covering the seventy miles of the trial at an average of 16mph and at times reaching a speed of over 30mph. This event, making the first passenger-carrying railway a practical reality almost a year later, heralded the start of the railway mania that gripped Victorian Britain for the next three decades.

It is difficult, perhaps, to imagine the excitement generated by the Rainhill trials, when viewed from the sophistication of the last quarter of the twentieth century. Fifteen thousand people converged on the village to watch the event and grandstands were erected along some parts of the line. Even the skew bridge, an ordinary enough structure to our eyes, was considered one of the architectural wonders of the age. The first bridge to be constructed at an angle to the railway it crosses.

In my painting, through the action of the figures and the dynamic lines of the composition, I have tried to express the excitement and vitality of the occasion. It is certainly one of my most successful paintings, having been widely exhibited and published, both as a print and a jigsaw and reproduced in many publications in the United Kingdom and overseas.

The 0-2-2 locomotive Rocket *was built by Robert Stephenson in 1829 and was subsequently the first loco purchased by the Liverpool and Manchester Rail-Road Company. The remains of the engine are preserved at the Science Museum in London.*

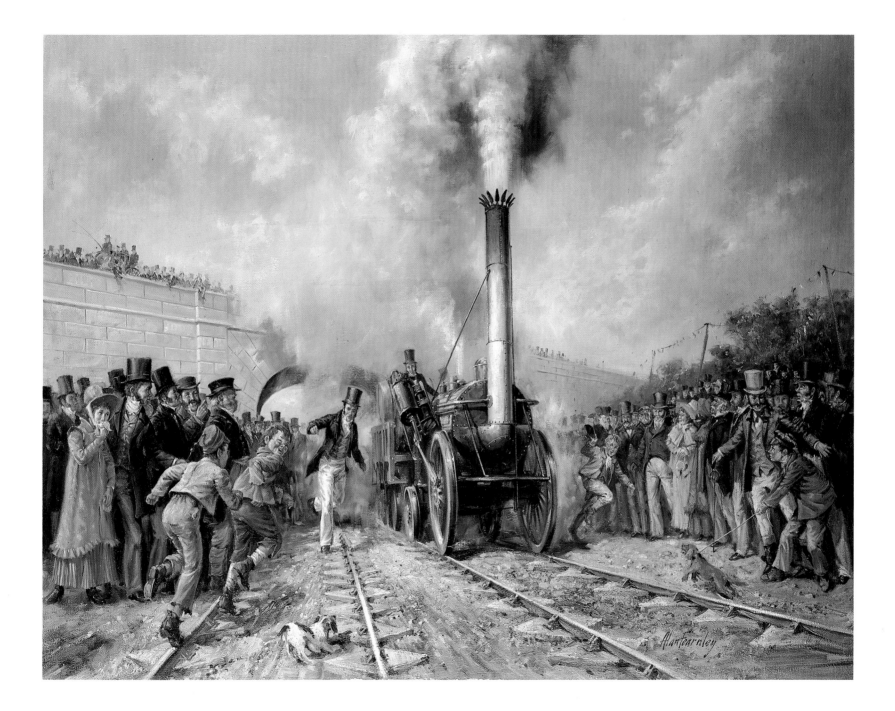

PRINCESS ELIZABETH AT EDGE HILL
36″×24″ Oil on Canvas

Princess Elizabeth storming under the road bridge at Edge Hill, after leaving Lime Street station at Liverpool. In this painting the main purpose was to try and capture the drama and excitement of a big steam locomotive working hard, but I must say that if the picture has succeeded in that aim, the credit is by no means entirely mine.

This was the last of three paintings commissioned by the late Bishop Eric Treacy, based, of course, on his own photographs. The first two had been completed and delivered when, whilst browsing through boxes of photographs at his home just before he retired, he asked me to pick out any that I would particularly like to paint. A very striking shot of the 6212 *Duchess of Kent* at Edge Hill had already caught my eye and we agreed that this would be the subject for his third painting. At the time Eric took his photograph, in the 1930s, when his parish was the Edge Hill district of Liverpool, 6212 was running with an experimental smoke box door, fastened with lugs around its perimeter. This gave the engine a very ugly appearance and, on deciding to alter that feature, it seemed a good idea to change its identity also, to that of the preserved member of its class, 6201 *Princess Elizabeth.*

Normally, even when a close resemblance is required between a painting and a photographic reference, I try to ignore such things as smoke effects, weather conditions etc, preferring to 'do my own thing' with those facets of the picture. In this case, however, my only contributions, apart from the colour, are the small group of workmen and the Black Five in the background. Eric was very fond of having a quiet word with the drivers before they pulled out of the station, telling them where he would be on the line and asking for a good show of exhaust when they got there. As the smoke cloud on my painting is very much as it appears on the photograph, it would seem that in this instance the driver entered whole-heartedly into the spirit of the plan.

Sadly, although Eric saw this painting in an almost finished state, he died before I could deliver it to him and it remained in my collection until it was sold to its present owner.

LMS Princess Elizabeth *Class 4-6-2 No 6201 at Edge Hill, Liverpool. A total of thirteen examples of W. A. Stanier's Princess class were built between 1933 and 1935 and in November 1962 the last survivor,* Princess Royal *was withdrawn. No 6201 and No 6203 are preserved.*

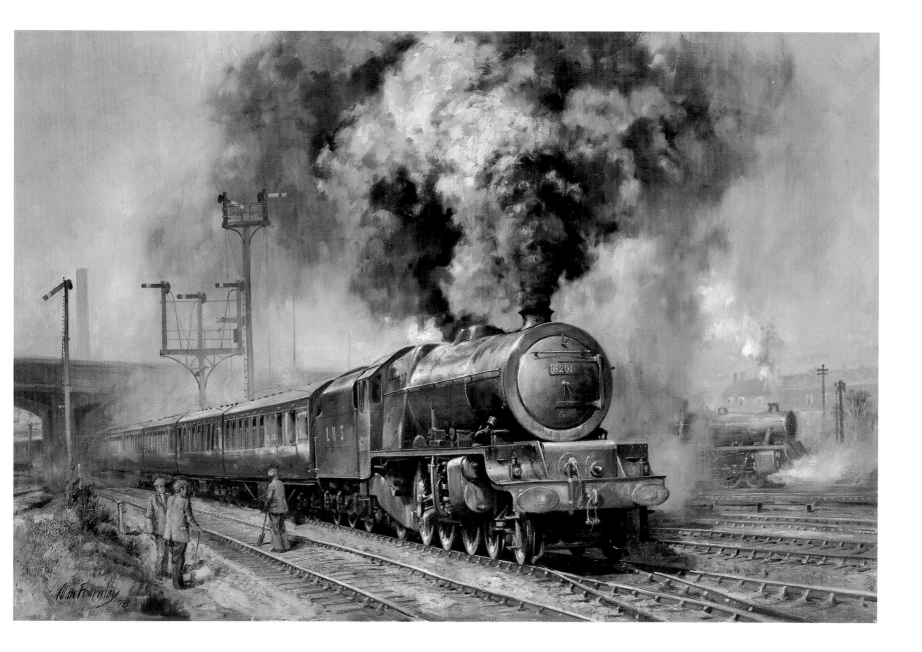

MIRFIELD'S JUBILEE
16″×12″ Oil on Canvas

Number 45708, *Resolution*, simmering in the early morning light beside the shed at Mirfield. I refer to this picture by the title above although it has not been titled through my own memory or recollection. Ken Breare is my dentist, Monday night drinking partner and occasional sketching holiday companion, and when he commissioned this painting, in answer to which of the class should be represented, he replied, 'Let's have *Resolution*, Mirfield's Jubilee'. Ken spent more time than I did in the forties and fifties sitting on the wooden fence which gave this view of the shed, so no doubt the title is well founded.

Mirfield station is hidden in this view, which looks towards the town, obscured by the water tank; and most of the mill chimneys in my picture have gone, although many of the mill buildings remain in use. The engine shed itself, originally built for the Lancashire and Yorkshire Railway Company, also remains more or less intact, but is now used to garage a fleet of road tankers rather than the assortment of mostly grime-covered freight locos I remember from my occasional forays as a train spotter. It is slightly surprising to me that my output of railway paintings has not included more examples of my immediate local area, but this example is one of only three with their subject as the line through Mirfield, although at the time of writing another one has been commissioned. This is all the more so as I find the re-creation of local scenes relating to my personal experiences has a certain satisfaction and relevance not found in 'foreign' settings, even though other subjects may appear more dramatic or inspirational.

The LMS 4-6-0 Jubilee class were a development by W. A. Stanier of Fowler's Patriot class and originally totalled 191 examples, introduced in 1934 although two were later rebuilt and reclassified. Three examples are preserved: No 45593 Kolhapur, *No 45596* Bahamas *and No 45690* Leander.

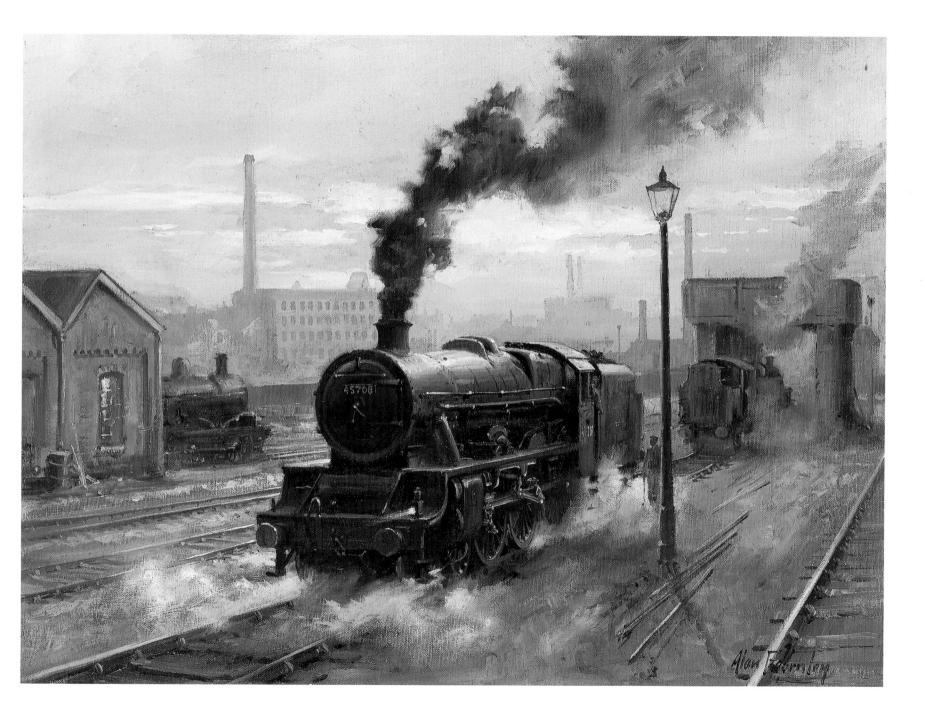

Alan Fearnley

THE NAVVIES
40″×20″ Oil on Canvas

In my opinion this is probably my most successful railway painting, getting away, as it does, from the more hackneyed 'locomotive picture'. It shows a group of navvies engaged in the backbreaking work of digging a cutting and laying track with only picks, shovels and crowbars during the latter part of the railway building age. The location is very loosely based on an old photograph of a bridge under construction on the Whitby to Scarborough line. Also shown on the photograph is the contractor's little saddle-tank locomotive with its strange wooden buffers and attractive tall chimney and spectacle windows. The bridge can be seen indistinctly in the distance on my painting but the foreground figures and activity are entirely imaginary. Much of the dramatic effect of the picture relies on the use of light and shade, strongly contrasting the figures in shadow against those in sunlight.

This must have been one of the most exciting eras of our industrial history providing an almost unlimited source of subject matter for paintings. When the M62 Motorway was under construction near my home in Mirfield, my two sons, Gavin and Lee, were at an age when boys are very enthusiastic about such things as bulldozers and tractors and I often took them to see the work in progress. Watching the huge earth-moving vehicles alter the very shape of the landscape was a vivid illustration of the supreme achievement of the railway navvies. With little more than their bare hands and the most simple of tools, these armies of workers created a vast intricate rail network taking only a little longer than it took to build a relatively small motorway system.

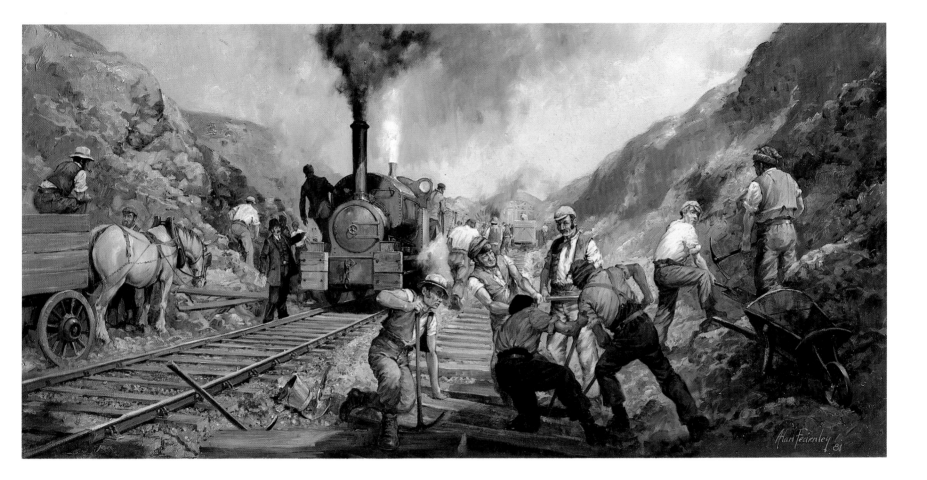

SNOW FREIGHT
30″×20″ Oil on Canvas

One of British Railway's Standard class 4 tank engines hauling a train of coal wagons. The industrial scene in the background is loosely based on Ryhope Grange colliery but not too much attention should be paid to that by anyone who knows Ryhope Grange well. The foreground details of track and signals etc, were painted accurately but the background structures were modified slightly, both in scale and shape to arrive at the desired result. The painting is really an exercise in using colours for effect, letting the warm tones of the sky light the locomotive and infuse the drifting exhaust, while contrasting with the cold blue shadows in the snow.

This painting has been one of my favourites ever since it was painted. Without being anything particularly outstanding in terms of technique or composition, it has an atmosphere and presence about it, a 'rightness' that makes it into a rarity; a painting which, looked back on over a period of years, I wouldn't want to alter if I came to do it again.

BR Standard Class 4 tank locomotive. One hundred and fifty-five of these two cylinder 2-6-4s were built by British Rail, being introduced in 1951 and the last examples withdrawn from service in July 1967.

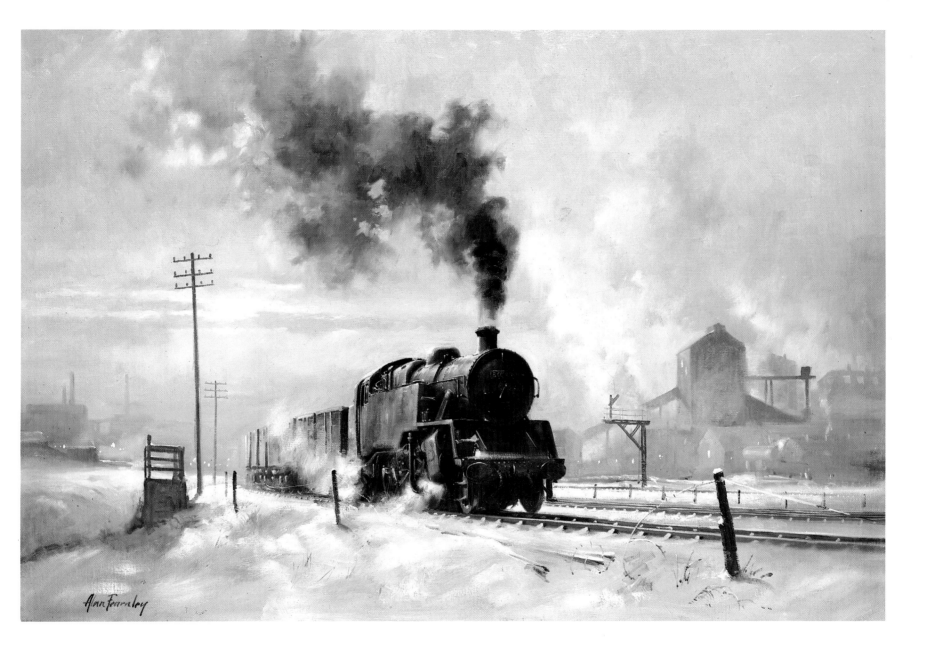

Alan Fearnley

WINTER ON THE SETTLE–CARLISLE
36"×24" Oil on Canvas

This picture of a 9F battling its way across one of the Settle–Carlisle line's many viaducts was painted to coincide with the centenary of the line in 1975. Having rather missed out 'professionally' on the celebrations held a year earlier for the 150 years of the Stockton–Darlington railway, I resolved to try and get my act together in time for the festivities surrounding the one hundred years of the 'long drag'. The effort proved very worthwhile and this painting was exhibited at the National Railway Museum, another was used for the cover of the official centenary brochure and one more was published as a postcard to coincide with the celebrations.

Stories of extreme weather conditions on the Settle–Carlisle line are legion. Of the line being blocked by snow drifts twenty feet deep at Dent, and of trains being halted because of the powerful winds. A wind once spun an engine uncontrollably on the turntable at Garsdale. As a teenager, I camped at Horton-in-Ribblesdale and at Ribblehead and well remember the 9Fs struggling up the long drag through the driving rain and moorland mists. In order to try and capture the wild bleakness of this, Britain's highest main line, in winter, I have used the most simple of concepts. A section of dark limestone architecture and a broken dry-stone wall are used to suggest the location, while the rest of the picture is dissolved into a steam and snow filled greyness.

BR Class 9F 2-10-0 were the last class of steam locomotives designed and built in Britain. The class comprised 250 examples built between 1954 and 1960, the last survivors being withdrawn in 1968. No 92220 and No 92203 have been preserved.

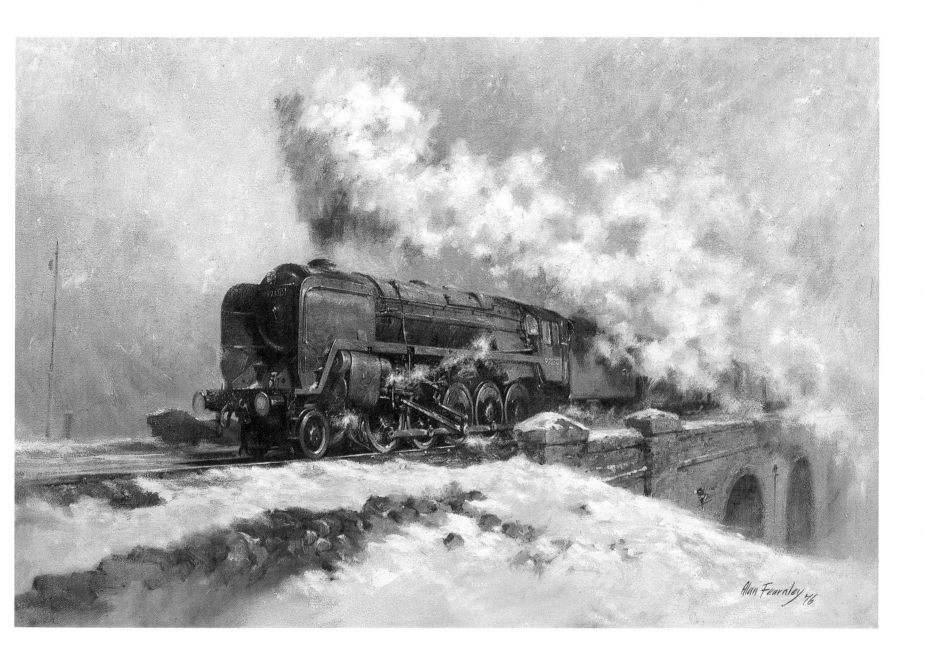

Alan Fearnley 76

LEEDS CITY STATION
24″×16″ Oil on Canvas

One of W. A. Stanier's rebuilds of the Royal Scot class No 46117 *Welsh Guardsman* pulling into Leeds, sometime around the late fifties. In their original form, as built by Fowler, the Scots, with their huge parallel boilers were very ugly locomotives but became pleasing enough when rebuilt, with an appearance in many ways echoing the Jubilees and Black Fives. The first engine was rebuilt in 1943 but it was twelve years before the entire class had been altered and from 1947 onwards they were fitted with the small curved smoke deflectors also found on the rebuilt Patriots and the two rebuilt Jubilees. Although LMS engines have featured in my paintings more than those of any other company, some subconscious reason has usually led me to choose Duchesses, Jubilees or Black Fives for portrayal and in spite of the prominence of the Royal Scot class this is one of only two of my paintings which depict them.

Railway stations such as Leeds with their girders and arches and filtering sunlight are fascinating and demanding places to paint, similar in atmosphere to loco sheds and round-houses but without the additional attraction of pools of oil and water, old wheel-barrows and ash rakes. Many years ago, as a painting exercise I attempted a picture, directly from a photograph, of the main concourse at Grand Central Station in New York. The painting was not a success but the memory of it came back to me when I caught the Amtrak there several years later, but, having been a jazz enthusiast since my early teens, the greater pleasure was in a piece of information flashed on the electric notice board 'For Harlem – Take the A Train!'

The 4-6-0 LMS Converted Royal Scot class were originally Fowler engines rebuilt under the direction of W. A. Stanier. They were introduced in 1943 and the class totalled 70 engines which were withdrawn from 1962 onwards. No 46100 Royal Scot *and No 46115* Scots Guardsman *are preserved.*

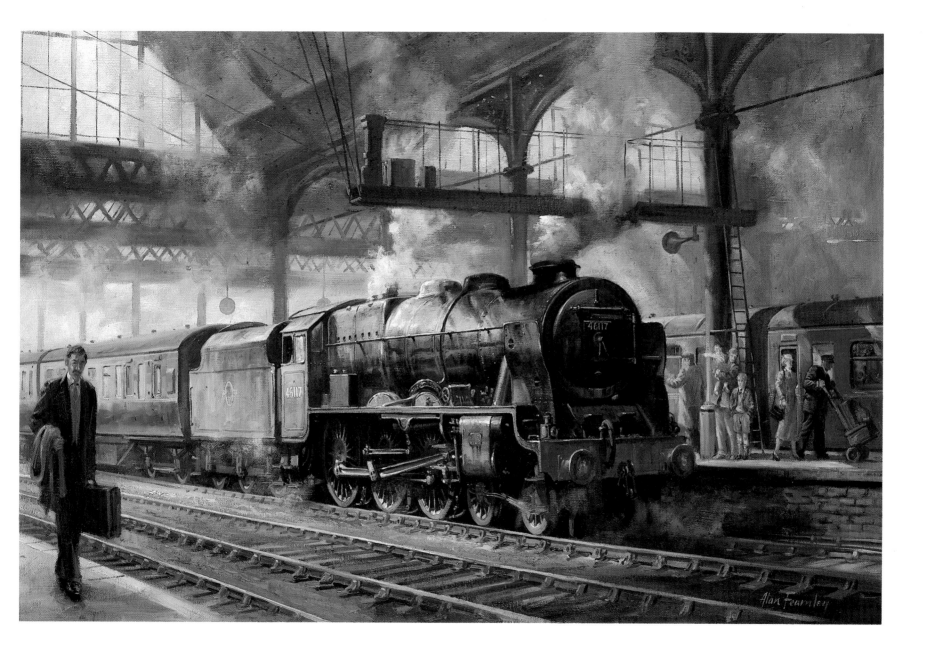

A DAY AT BOVEY TRACEY
36"×24" Oil on Canvas

This picture is derived from photographs of charabancs, one of the many road vehicle services provided by the Great Western Railway, queuing up at Bovey to meet excursion passengers, having a day in the country, away from the Torbay beaches. Their destination would then be the granite tors and outcrops on nearby Dartmoor. This was, of course just one example of the comprehensive range of services the Great Western Railway provided for its holiday trade in the south west.

In the late 1920s, the time around which this scene is set, a trip to Bovey must have been a particularly popular day out, as in some photographs as many as five or six charabancs are pictured. My own holidays in Devon have, for the most part, been blessed with warm sunshine, but it seemed more appropriate and typical of the popular conception of holidays in Britain to paint the scene in the more dismal conditions of a showery summer's day. It also provides a contrast in atmosphere to that which might have been expected in a picture with this subject matter.

In contrast with other British railway companies, the Great Western Railway does seem to have had more than its fair share of idyllic, branch line backwaters. Perhaps, in the early days of railways, most lines outside the urban areas were idyllic in atmosphere but the industrialisation that spread out along the then main lines of communication were less apparent in the remote Great Western territories of Devon and Cornwall. Whatever the reason, the line from Newton Abbot to Moretonhampstead, on which Bovey is situated had that air of placid tranquillity. Unfortunately the line is no more, most of it closed shortly before steam also came to an end, and the terminus is now at Heathfield, two miles short of Bovey Tracey.

GWR 2-6-2T at Bovey Tracey, c1928, one of the Churchward 45 XX class built just after the turn of the century, the last survivor being withdrawn in the autumn of 1964.

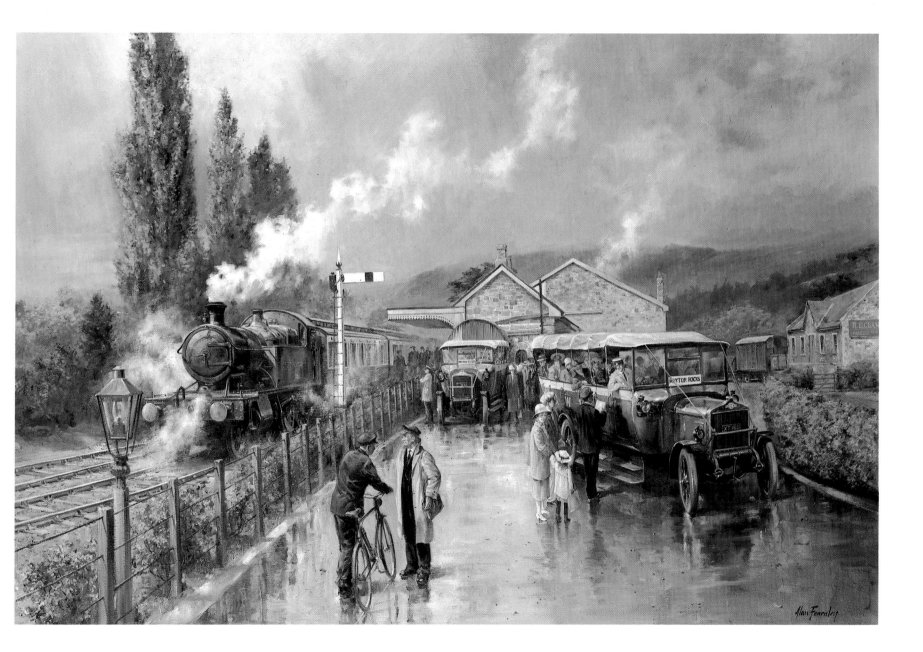

THE LONG DRAG
30″×18″ Oil on Canvas

With a backdrop of Pen-y-Ghent merging into the clouds of an approaching storm, ex LNER A3 No 60066, *Merry Hampton* passes the hamlet of Selside on the long haul from Settle to Ais Gill summit. The Settle to Carlisle line is without doubt one of the the most scenic in the British Isles, and the area where the railway threads its way between the three peaks of Pen-y-Ghent, Whernside and Ingleborough is where the scenery is at its most dramatic. In my painting, the ragged billows of wind-swept smoke and the sharp contrast between the sunlit foreground and the mist shrouded hills have been used to convey the wild, continually changing nature of the area. The painting was in fact commissioned by an expatriate Yorkshireman, now living in Canada, to remind him of his native fells and dales where, like me, he hiked and camped as a boy.

The LNER policy on naming locomotives seems to have been rather more extrovert than that of the other main railway companies. They all had their various Kings, Queens, Duchesses, Princesses, Castles and Halls etc, names in keeping with the dignity of respected railway companies. In contrast, the LNER named their engines after racehorses, football teams and, it seems, almost anything that came to mind. Consequently the company roll-call included such splendid examples as *Blink-Bonny, Robert The Devil, Tudor Minstrel, Madge Wildfire, Herringbone* and to my mind, the best of all, *Wolf of Badenoch*. It has been nice to see in recent years that British Rail have reintroduced a policy of naming locomotives but I think it may be some time before they achieve the wilder flights of fancy of the old LNER.

The LNER 4-6-2 Class A3 locomotives eventually numbered seventy-eight in all, of which fifty-one had been rebuilt from LNER Class A1. Built under the direction of Sir Nigel Gresley between 1922 and 1935 the last in service was withdrawn in 1966. No 4472 Flying Scotsman *has been preserved.*

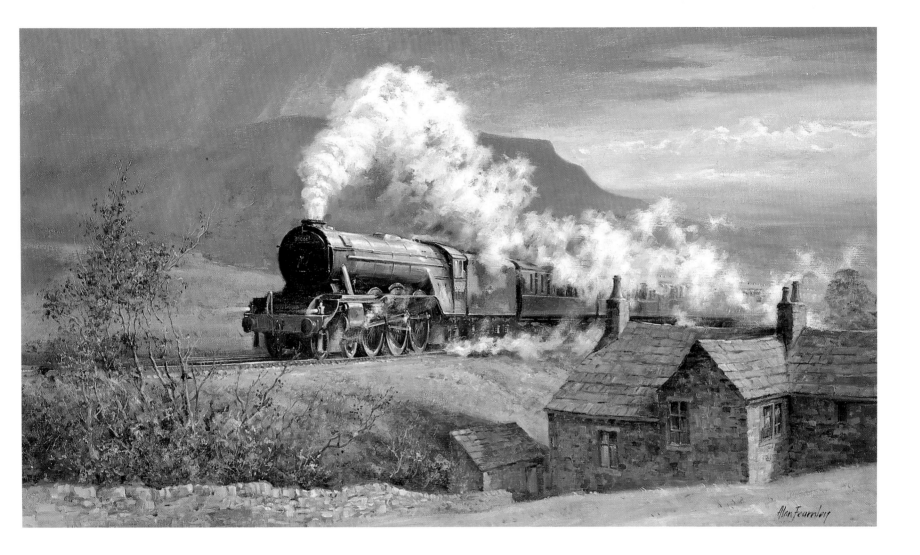

DUCHESS OF BUCCLEUCH AT SHAP WELLS
36″×24″ Oil on Canvas

This was my first commission painted for the late Bishop Eric Treacy, based on one of his best known photographs, and, as it was his first choice as a subject for a painting, presumably one of his own personal favourites out of the many thousands he took. He certainly remembered exactly the day when it was taken, recalling, when we discussed the painting, the lowering sky and the blustery wind bringing squally showers over the moors, as the big Pacific lifted its heavy, war-time train away from Shap Wells. In the painting, the subject is pictured in pre-war LMS livery, but the weather conditions have been retained and a few gangers maintaining the track added for good measure.

Upon completion, Eric collected the painting from my house and it was obvious how pleased he was with it, both from his comments and expression. However, within an hour of his leaving to return with the picture to Bishop's Lodge, he telephoned me in a most upset and distressed state. He had taken the painting out of his car and propped it on a garden table to admire it. As he stepped back, a gust of wind had blown it over and the canvas had been ripped as it fell by the corner of the table. He was quite distraught. Half an hour later he was back at my house with the painting and he and I, and my eldest son, Gavin, surveyed the damage. The tear was bad, but was in the smoke area of the canvas and there seemed to me a good chance that I could repair it and cover the damage by repainting that area with a heavy impasto technique. On hearing this news Eric was obviously greatly relieved, and, after telling us again how the terrible accident had happened, he turned to my son and said 'There, if you think I'm a clot you can say so'. To my horror, but Eric's amusement, with the innocence and honesty of an eight-year-old, Gavin bluntly told His Lordship the Bishop of Wakefield that he was a clot.

LMS 4-6-2 Princess Coronation class more commonly known as 'Duchesses'. Designed under the direction of W. A. Stanier and built between 1937 and 1948, the class numbered thirty-eight examples of which twenty-four were originally streamlined. The last engine was withdrawn in October 1964. No 6235, No 6229 and No 6233 are preserved.

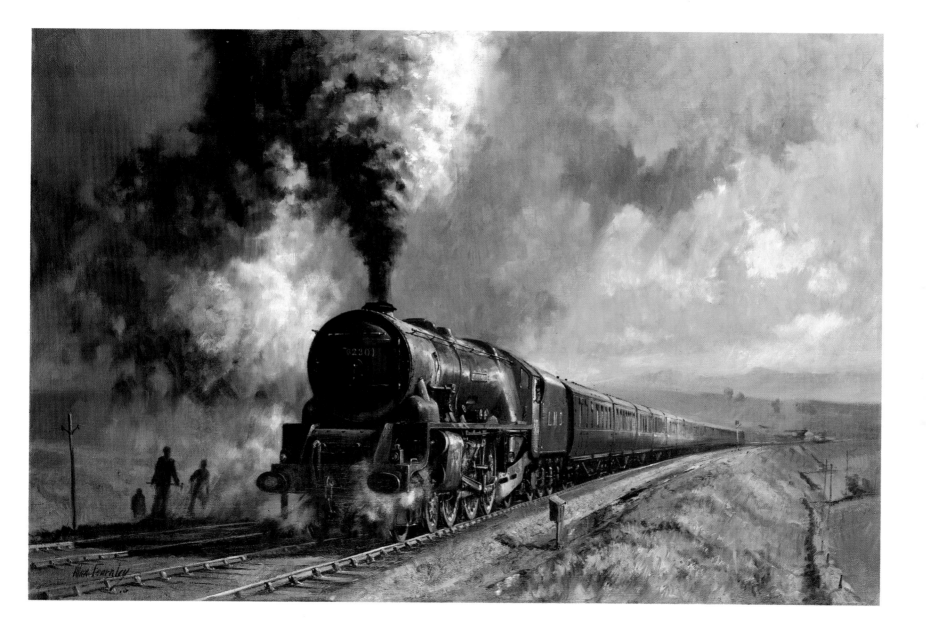

LYDGATE VIADUCT TODMORDEN
36″ × 28″ Oil on Canvas

Todmorden stands at the very head of the Calder valley, almost at the border with heathen Lancashire, and is seen in this view from the group of stone houses which cling to the hillside behind Lydgate viaduct. The tall mill chimneys, rows of terraced houses and the Pennine moors, crowding in on all sides, are elements both typical and symbolical of my native West Riding. Until the mid 1960s, the Fowler 2-6-0 Crab with its rake of coal wagons seen in the picture would have been another typical element in the scene.

Several of the old mills have been demolished in recent years or at least denuded of their tall chimneys and some of the terraces of houses have also disappeared, resulting in a rather different view from Lydgate today. This painting was originally conceived after seeing a photograph by Ian Krause who, hopefully, will not be offended if I describe him as being of the admirable Colin Gifford school of railway photographers. However, it is doubtful if he would recognise much similarity between his picture and mine as I have chosen a slightly different viewpoint and combined imaginary elements with what was actually there in the days of steam and what remains there today.

One building that has remained unaltered is the one with white window frames immediately above the coal wagons on the left of the picture. It is the Robinwood Junior School. Imagine the problems, during the days when traffic on the line was heavy, of trying to teach with a double-headed and banked coal train just a few yards outside the window struggling up the incline to the summit at Copy Pit. I'll bet all the kids loved it.

LMS Hughes/Fowler 2-6-0 mixed traffic locomotive on Lydgate viaduct just to the north of Todmorden. Known universally as Crabs, 244 of these engines were built between 1926 and 1932 originally for freight duties but later reclassified 5MT. The last was withdrawn from service in 1967 and No 42700 and No 42765 are preserved.

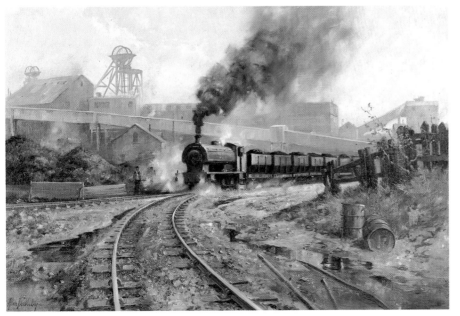

COLLIERY ENGINE
30″×20″

A Hunslet 0-6-0 saddle tank engine hauling a rake of coal wagons through a colliery would have been a common sight in almost any of the British coalfields until the late 1970s. Some collieries even kept their steam locomotives working into the early 1980s. The Hunslet 0-6-0s were among the larger engines employed for industrial use among the 0-6-0s and 0-4-0s by such builders as Bagnalls, Manning Wardle and Andrew Barclays.

The 0-6-0 saddle tank was designed by the Hunslet Engine Company for the Ministry of Supply and several hundreds were built between 1943 and 1946. Seventy-five were purchased by the LNER.

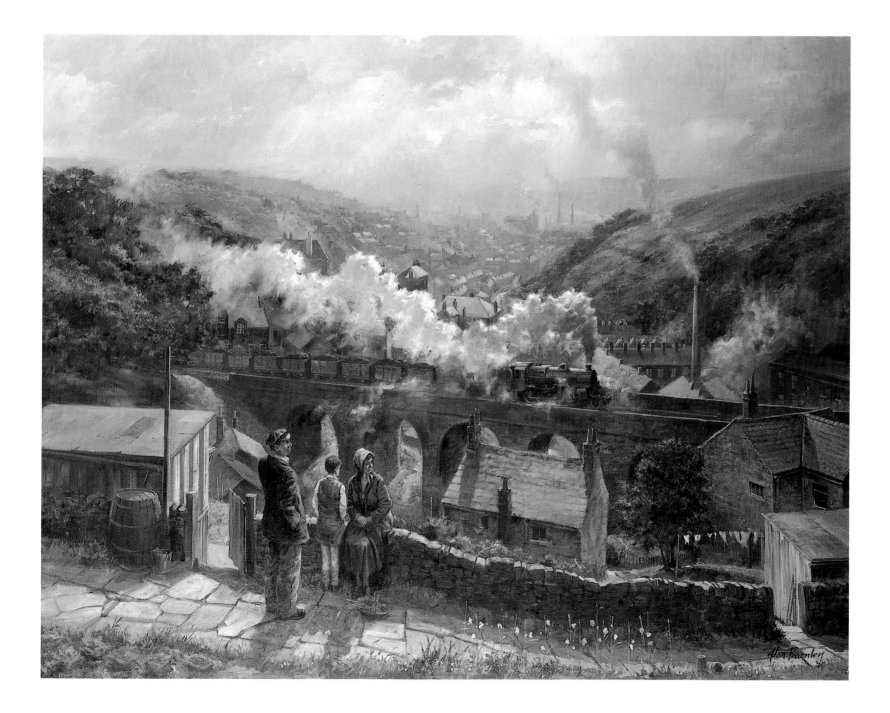

THE EARLY HOURS, SHILDON
30″×20″ Oil on Canvas

In the dawn twilight of 31 August 1975, No 4498 *Sir Nigel Gresley*, Stirling Single No 1, and No 4472 *Flying Scotsman* raise steam behind the silhouetted shape of T2 No 2238, in the carriage works yard at Shildon, County Durham. That was, of course, the day of the Grand Steam Cavalcade, held to celebrate the 150 years of railways since Locomotion No 1 first ran on the Stockton to Darlington line, and it remains for me an unforgettable experience.

A photographer friend, Saville Walker, and I, arrived at Shildon very early on the day of the cavalcade, although, perhaps not quite as early as the time indicated in my painting. Then, along with the rest of the rapidly growing crowd, we spent the first half of the morning craning our necks at the few vantage points we could find which gave a view into the yard. By ten o'clock we thought it was time to stake our claim to a viewpoint overlooking the main event.

Although we had bought tickets for them, the grandstands were obviously of no use to us, being much too close to the track and on the shadow side of the engines, so we joined half a dozen other people at the top of a gently sloping field to the south of the line. With mounting apprehension we watched the field gradually fill with hundreds of other enthusiasts, dreading the mêlée that might ensue when the cavalcade arrived, if everyone blocked the viewpoint of everyone else. We need not have worried. For the entire afternoon all those who had come only to watch remained seated, while the photographers stood in an orderly, considerate line behind them. Everyone had an excellent view, the sun shone, the thirty-four locomotives looked magnificent; it was a perfect day.

The wonderful, relaxed atmosphere of the event at Shildon seemed to be lost entirely five years later at Rainhill, during the Rocket 150 celebrations. The steam exhibits were as good as ever, but consideration and good humour were qualities sadly lacking in the grandstand where our compulsory, expensive seats were located. The whole affair had an air of commercialisation about it, and we came away feeling somehow let down and exploited. It was a day that served to emphasise just how exceptional the Shildon experience had been.

LNER 4-6-2 Class A4 locomotives were built under the direction of Sir Nigel Gresley and introduced in 1935. The class numbered a total of thirty-four, one of which No 4468 Mallard *holds the world speed record for a steam locomotive. The last members of the class were withdrawn in September 1966 and four have been preserved in Great Britain and one in Canada.*

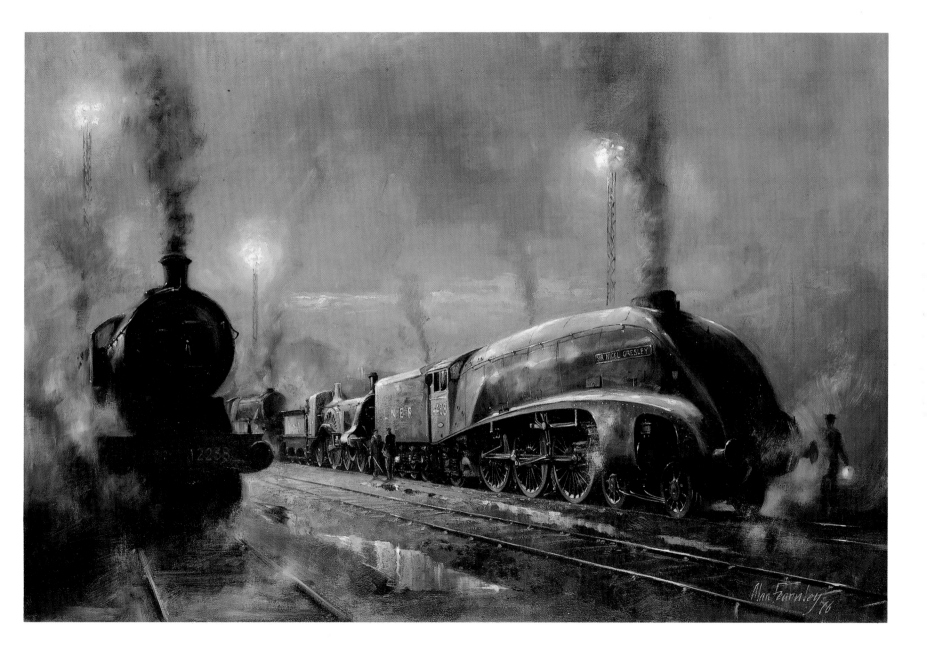

SUNSET AT NINE ELMS
40″×24″ Oil on Canvas

Nine Elms, the Southern region's main London depot, is located on the south bank of the Thames, not far from Battersea power station seen in the background here adding its share of pollution to the smoke from the shed. In the 1950s, up to a dozen of Bullied's Merchant Navy Pacifics were stabled at Nine Elms, but *Holland-Afrika Line* shown in my picture is a visitor from its home shed of Exmouth Junction. To my eye, in their rebuilt form, Bullied's Pacifics rank with the Coronations and Britannias as Britain's best looking steam locomotives.

During the days of steam on British railways the opportunity to actually get into a steam shed never arose, but in 1978, at a time when wildlife subjects as well as transport formed part of my output, the opportunity came to go to South Africa and, between game parks, visit the sheds in Capetown and Germiston. The contrast between the two was considerable. At Capetown the gatekeeper hardly glanced at my pass before saying, with an expansive gesture, 'There it is, my friend. Help yourself.' I was then able to wander around the shed at will, unaccompanied, for as long as I liked. It all appeared much as photographs show British sheds towards the end of steam, generally grimy and unkempt with piles of ash and debris, and large pools of oily water; on the wet, dismal day when I was there, the atmosphere was tremendous!

At Germiston, however, my pass was carefully inspected and questions asked to confirm where and when it had been issued and then, after a wait of half an hour or so, a guide was provided to conduct me around the depot. It was a bright sunny day and everywhere seemed to have been freshly swept and tidied with all locomotives clean and in good order. Somehow, it did not seem half as real as Capetown.

4-6-2 Class 8P Merchant Navy No 35023 Holland-Afrika Line *at Nine Elms c1959. Built by Mr O. V. Bullied for the Southern and introduced in 1941, the class numbered a total of thirty engines.*

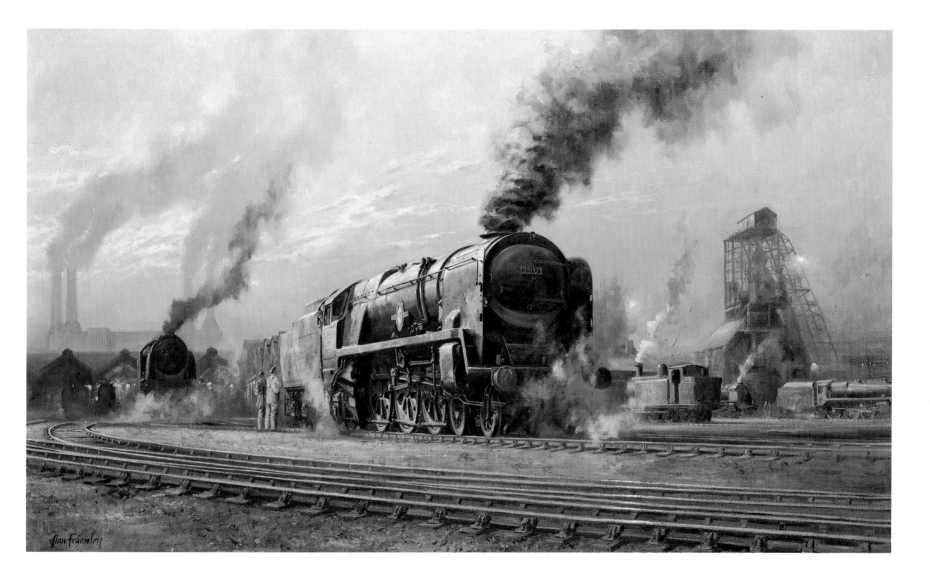

RAMSGATE STATION
36"×24" Oil on Canvas

Ramsgate soon after the turn of the century, when the holiday makers or day-trippers from the metropolis could alight from the train and almost step directly onto the sands, having been hauled behind a brass and copper encrusted locomotive, resplendent in the ornate green livery of the South East and Chatham Railway. The station survived in this location until 1926 when a new line was opened to give through running round the Kentish coast. In this painting I have contrasted a Stirling Class A 4-4-0 waiting in the siding and almost at the end of its life, with, pulling out of the station, a Wainwright D Class 4-4-0 at the start of a career that would last into British Rail days.

It seems unlikely that the years before World War I can have been quite so halcyon as they seem, viewed from eighty years on. Pictorially though, the elegance of dress and architecture to which, apparently, Ramsgate station was an exception, and the ornate quaintness of locomotives and rolling stock, give an air of serenity to the scene which diminished over the following decades until disappearing altogether by the time nationalisation came along.

In the foreground is one of the James Stirling designed Class A 4-4-0s originally built for the South Eastern Railway at Ashford between 1879–81. A total of twelve examples were built and all were withdrawn by 1909. In the background is one of the D Class 4-4-0s designed by H. S. Wainwright and built between 1901 and 1907. This class numbered fifty-one engines, the last one being withdrawn in 1961. No 737 is preserved in the national collection.

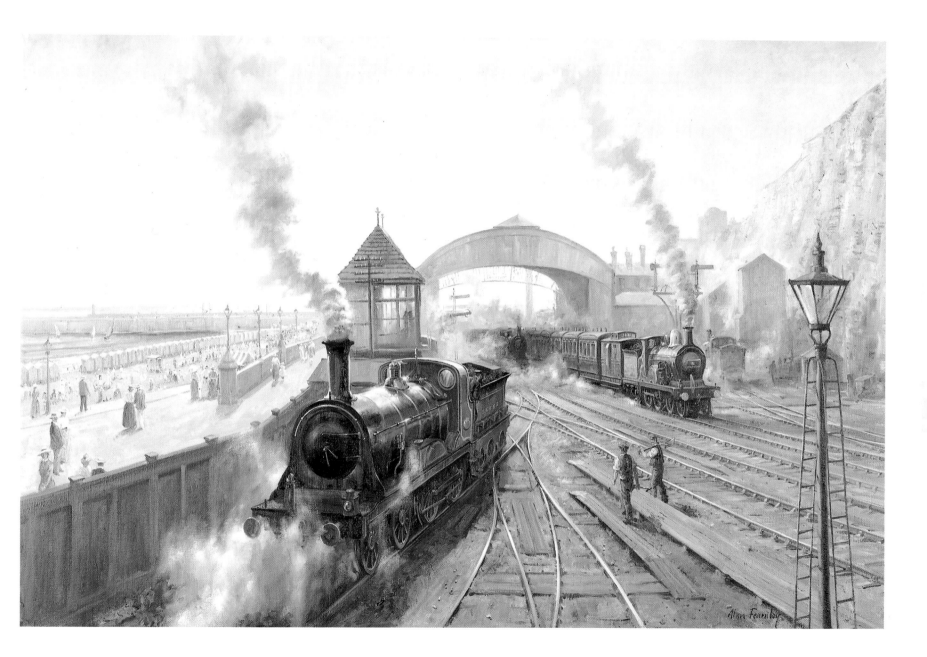

THE DUKE ON CAMDEN BANK
36″×24″ Oil on Canvas

This is a painting that was commissioned by the 71000 (Duke of Gloucester) Steam Locomotive Trust of their unique engine for publication as a limited edition print. *The Duke* is shown here soon after leaving Euston station, working hard on the incline of Camden Bank with the *Midday Scot*. The scene must be fairly early in the engine's career as it proved to be so unreliable and erratic that it soon became relegated to less important trains and freight workings.

It is now apparent, thanks to research done by the 71000 Trust, that *The Duke*, BR's only Class 8P locomotive, was perhaps condemned to this humiliation without a fair trial. During the mammoth task of rebuilding undertaken by the Trust, they discovered various mistakes which had been made, both in manufacturing the engine wrongly, and in alterations imposed on the design while the engine was being constructed. These they corrected, rebuilding *The Duke* as the designers had originally intended. The improvement in performance has apparently been nothing less than dramatic, and when Peter King, the Trust's secretary, told me 'Honestly Alan, she goes like a rocket', I don't think that it was a comparison with any other steam locomotive.

The prints were a great success and were countersigned by Mr R. A. Riddles who conceived and designed the engine, Mr L. T. Daniels, the designer of the British Caprotti valve gear and Mr J. F. Harrison who was CME of the LM region in 1954 when *The Duke* was built. The money raised was used to provide a new chimney, this time of the correct dimensions! It was a proud moment for me when I was invited to a small ceremony when the members of the 71000 Trust presented the original painting to their honorary president HRH Prince Richard, The Duke of Gloucester.

BR Class 8P, 4-6-2, three cylinder locomotive No 71000 Duke of Gloucester *was built under the direction of Mr R. A. Riddles in 1954. No 71000 was the only member of the class to be completed and was withdrawn in 1964. Preserved by the 71000 Steam Locomotive Trust at Loughborough.*

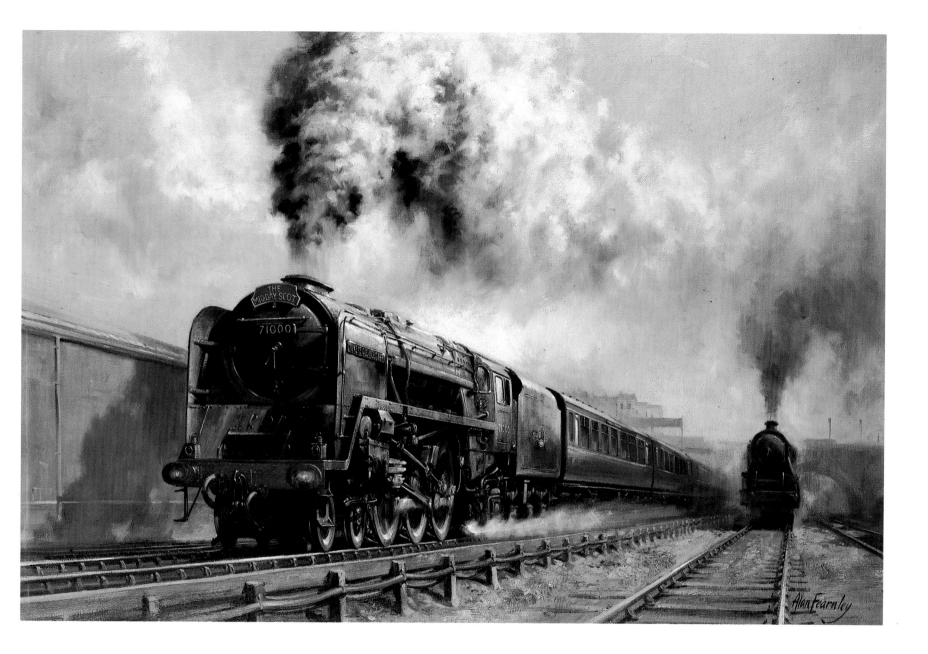

EVENING STAR AT HAWORTH
36″×24″ Oil on Canvas

This is a more recent scene than most of the others portrayed in this book, dating from the early 1970s when *Evening Star* was on loan from the national collection to the Keighly and Worth Valley Railway and based at Haworth. Starting at Keighley and running up the steeply graded valley of the River Worth, the KWVR line changes from a West Riding industrial environment, with what I think of as a proper 'northern railway' atmosphere, to a tranquil rural setting of meadows and heather covered moors at the Oxenhope terminus only a few miles later. Although now slowly changing, at the time the picture was painted, the terraced stone houses, cobbled streets and small mills which surround the station and shed yard at Haworth had changed little since the turn of the century. The whole atmosphere of the railway was that of an integral part of the community rather than, as is so often the case, a quaint anomaly kept alive by a group of enthusiasts.

In fact the only element which did, perhaps, look out of place was the collection of locomotives, rolling stock and bits and pieces, from almost every region, all in varying stages of neglect, dismemberment and restoration which filled most of the sidings. Prominent among this motley clutter was the now beautifully restored *City of Wells*, at that time forlorn and rusty and looking for all the world as though she would never again turn a wheel.

The picture shown here is one of three painted around the same time and from exactly the same viewpoint. Two are of *Evening Star* and the Ivatt 2-6-2T, the third was the first of what might be called my real railway pictures, already mentioned earlier in this book, of a BR Standard Class 4, No 80002.

BR Class 9F 2-10-0 No 92220 Evening Star, *the last steam locomotive built for British Railways in March 1960, outside the engine shed at Haworth. The 9F Class comprised 250 engines introduced in 1954 with the last being withdrawn in June 1968. Nos 92220 and 92203 are preserved.*

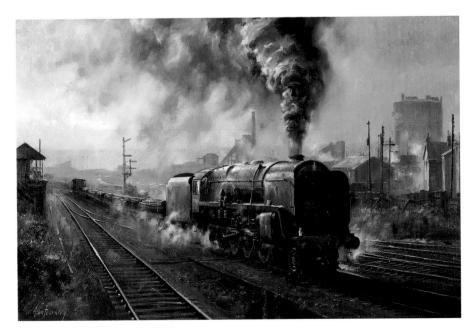

9F at CONSETT
30″×20″

A 9F 2-10-0 leaving Consett Steelworks and passing Carr House West signal box with a train carrying steel billets. This is one of the 9Fs allocated to Tyne Dock and fitted with twin air pumps which were used to open the hopper doors on the trucks when the engines hauled the very heavy iron ore trains from the docks to the foundry.

BR Class 9F 2-10-0 were the last class of steam locomotives designed and built in Britain. The class comprised 250 examples built between 1954 and 1960, the last survivors being withdrawn in 1968. No 92220 and No 92203 have been preserved.

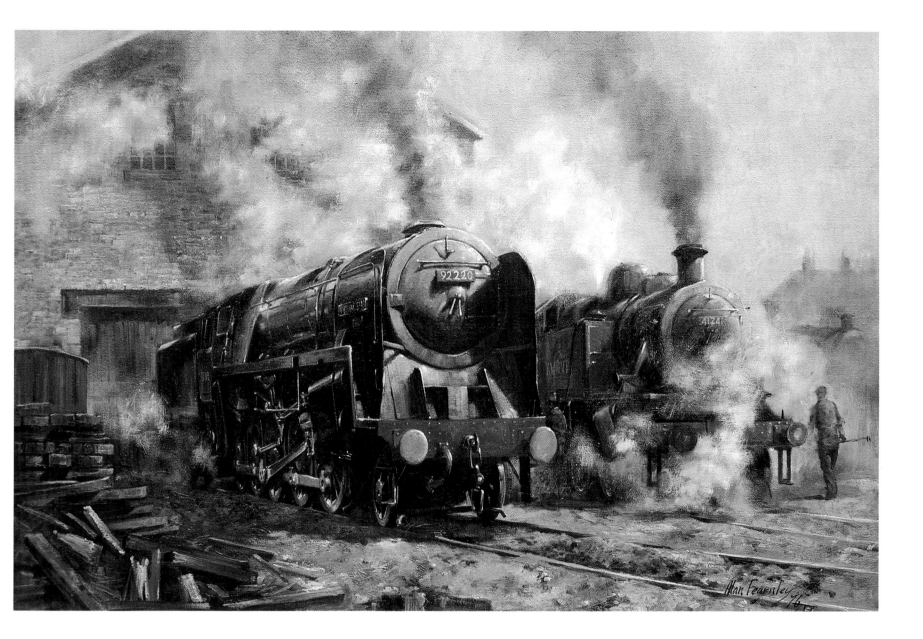

DAY'S WORK DONE
36"×28" Oil on Canvas

A Black Five steams slowly home towards Preston with the sun setting behind it over the Irish Sea. The scene is an idealised and sentimental one but I make no apologies for that. The portrayal of steam locomotives in the landscape, in an age of electric trains which ignore hills and tilting trains which ignore corners, is bound to have an element of sentimentality about it. The idealism, hopefully, is in a similar vein to that seen in many early Victorian railway prints by such artists as J. C. Bourne, Thomas Bury and A. F. Tait. My aim was to show the harmony with, and response to, the elements which the steam locomotive shares only with the vessels in marine paintings, and is entirely absent from the modern railway scene. This is an aspect of railway painting that, along with the involvement of the human element, I have more belief in than the simple, though more popular, portrayal of a favourite locomotive.

The bridge seen in this picture carried the line from Preston to Southport across the River Douglas, a few miles inland from its junction with the estuary of the River Ribble. The river is tidal and was navigable at high water as far as the start of the canal system leading to Wigan and Manchester, necessitating the use of a swing bridge to allow access for the coastal sailing barges. The line, along with so many others, was closed in 1964 and the bridge demolished.

LMS 4-6-0 Class 5P5F, commonly known as Black Fives, designed by Mr W. A. Stanier and introduced in 1934, the last of 842 examples being built in 1951. Nos 44871 and 44781 hauled BR's last official steam train on 11 August 1968. Thirteen examples are preserved.

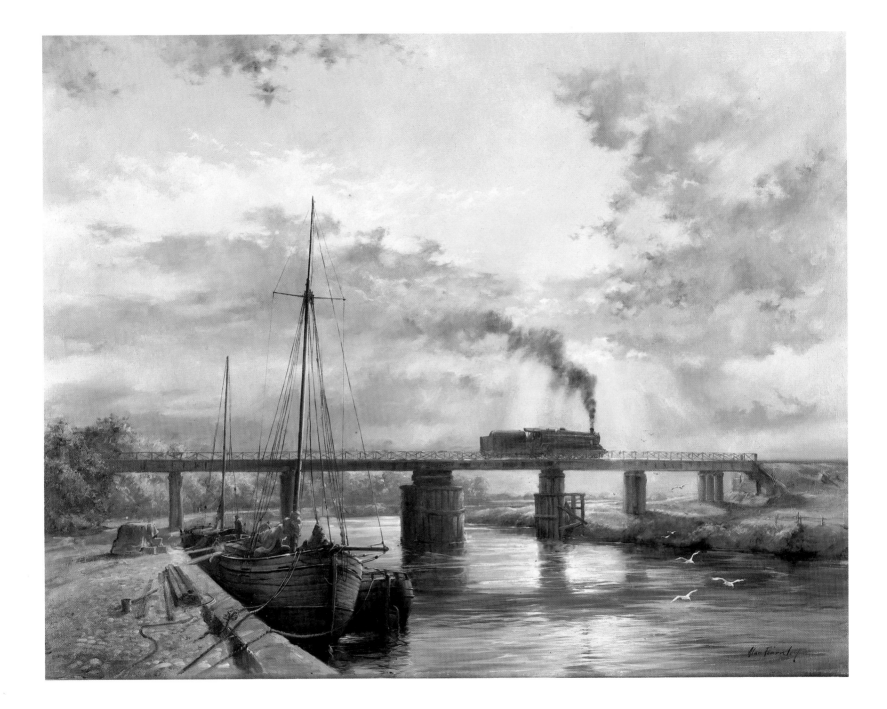

OIL SKETCHES

Oil sketches are, to me, a pleasant and light hearted diversion from more serious paintings and large scale compositions. Their success depends almost as much on an attitude of mind, as it does on subject matter and skill and the sense of relief that can be achieved by dashing off one of these small carefree pictures can be quite therapeutic during long periods of struggle with some troublesome large work which never seems to move any nearer to completion.

A well known phrase in painting is that 'it isn't what is put in that is important, so much as what is left out,' and nowhere is that more true than in the concept of the sketch. The whole essence of the technique is to apply the paint in a vigorous, first time attack, and then have the nerve to leave it alone, relying on the freshness and spontaneity of the effect to make up for any shortcomings in modelling, drawing and definition etc. Some subjects seem to lend themselves to a sketching style more than others, and in the field of railway painting this seems to apply particularly to small engines with distinctive features such as large chimneys and domes or ornate brass work. A Coronation, Britannia or an A3 seem to demand more than just a sketch or perhaps they haven't sufficient personality for it to be captured in just a few quick brush strokes.

GWR Class 4800, 0-4-2T, built by C. B. Collett and introduced in 1932. A total of seventy-five were built.
Furness Railway 0-4-0 goods engine with inside cylinders, designed and built by Edward Bury. A Coppernob of 1846 is preserved by the National Railway Museum.

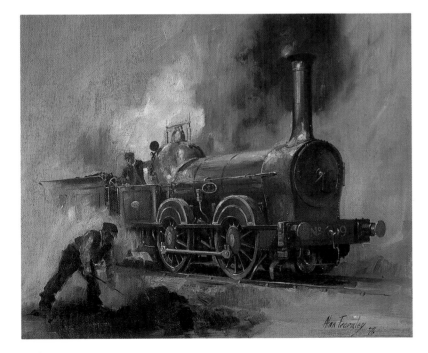

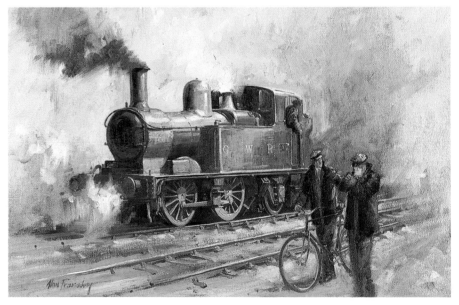

FURNESS RAILWAY COPPERNOB
20″×16″ Oil on Canvas

GWR 0-4-2T
20″×14″ Oil on Canvas